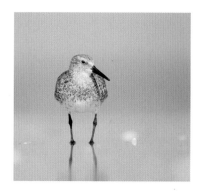

THE BIRDWATCHER'S GUIDE TO DIGITAL PHOTOGRAPHY

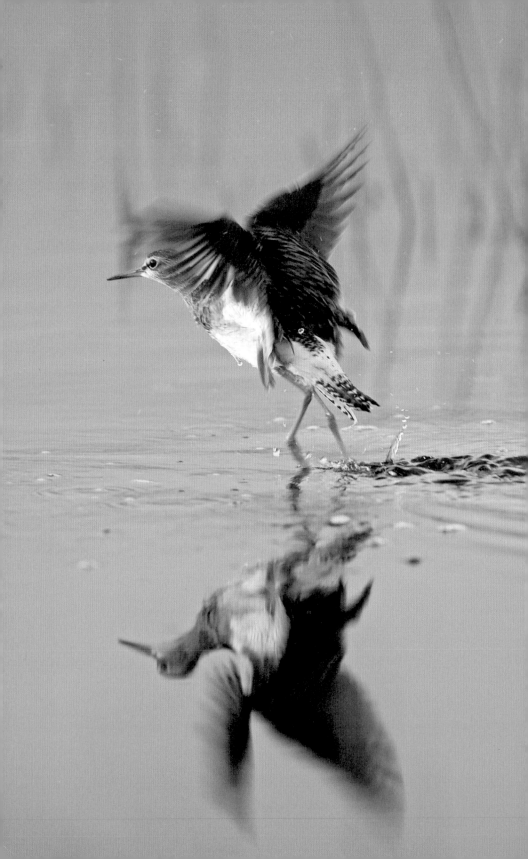

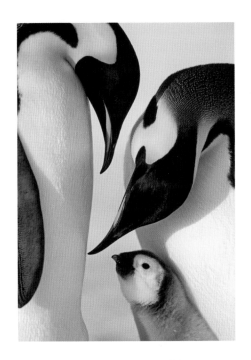

THE BIRDWATCHER'S GUIDE TO DIGITAL PHOTOGRAPHY

David Tipling

THUNDER BAY
P·R·E·S·S

San Diego, California

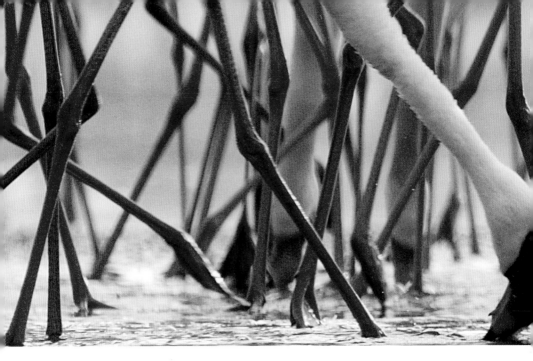

Thunder Bay Press
An imprint of the Advantage Publishers Group
5880 Oberlin Drive, San Diego, CA 92121-4794
www.thunderbaybooks.com

ISBN 13: 978-1-59223-608-4
ISBN 10: 1-59223-608-1
Library of Congress Cataloging-in-Publication Data available
upon request.

Printed in China
1 2 3 4 5 10 09 08 07 06

Contents

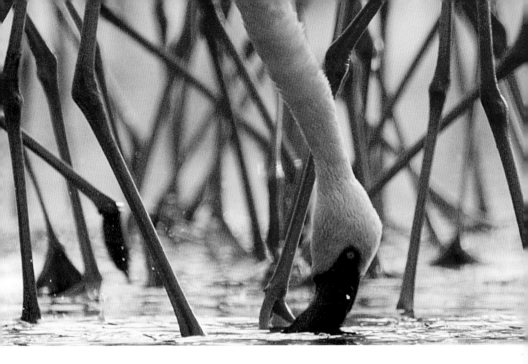

Foreword

Never in the history of ornithology has a technological revolution occurred with such lightning speed and profound impact as the arrival of the digital camera. Until recently it was professional photographers who produced most of the informative images found in books, journals, magazines, and on the Internet. The financial outlay, advanced technical skills, and patience required to capture outstanding bird pictures were prohibitive to most amateur photographers. Today, digital equipment and software allow even casual naturalists to produce both beautiful and useful pictures of birds, with only modest investments in resources, time, and practice. Moreover, the Internet now provides a readily available global forum for these images. This "democratization" of photography now produces a tremendous wealth of new information on identification, plumage variation, behavior, distribution, and ecology of birds.

While the move to digital allows the amateur access to the previously exclusive world of the professional photographer, regularly achieving award-winning shots requires a lifetime's dedication. David Tipling comes from this position to share his hard-won expertise, so that this resulting book is an amazing treasure trove of hardware advice, field tricks, artistic nuances, and even editing techniques—all fantastically useful to the amateur and professional alike.

Tipling's numerous awards are richly deserved, for his pictures are both technically superb and brilliantly composed. Often with elegant photographic structure, he captures

© Jon Reis/www.jonreis.com

birds absorbed in their daily rituals. Thus, each picture teaches us something about the bird while also evoking our deeper appreciation for the beauty of life. Thanks to the scores of practical hints presented in this book, the rest of us can now share in his skill.

Professionals and amateurs alike will want to consult this book, and I predict that the results will be visible all over the Internet before long. I, for one, cannot wait to get back outside and use some of Tipling's advice to improve my own, humble photographic efforts in the scrubs of Florida and the swamps of Arkansas.

Dr. John W. Fitzpatrick
Director, Cornell Lab of Ornithology

Introduction

**Twenty-five years ago I picked up a camera for the first time, and
armed with this and a telephoto lens, I set out to photograph birds.
I had little idea of how to take good pictures, other than realizing I
needed to get close. My hunting grounds were the fields and lakes
near my home in the southeast of England's countryside. Here I honed
my skills, studied the local birds, began to understand their behavior,
and so slowly learned how to approach birds without causing alarm.**

Like many who have caught the bird photography
bug, I became hooked, and I can admit that
my pastime took over my life. My shameless
addiction lasts to this day, and my desire to take
pictures burns as bright now as it has ever done.

Many technological advances have come
along over the last quarter of a century. When
I started, most bird photographers shot in black
and white, autofocus (AF) lenses had not been
invented, and the digital age was science fiction.
However, while the tools of the trade may have
changed, many of the techniques used in our
wonderful pursuit have not.

What has changed is the ability to
photograph birds successfully with the aid of
modern digital equipment. Never before have
we had so much control over the finished
image—whether you are a photographer wanting
to create artistic images or a birdwatcher with a
desire to record what you see, the opportunities
made available by ever-improving cameras
and lenses continually push the boundaries of
what is possible. The digital revolution has not
only raised standards in bird photography but

has also encouraged a whole new audience of
birdwatchers to pick up a camera and try their
hand at this thrilling pursuit.

The jargon-filled world of digital photography
can seem daunting at first—bits and bytes, Levels
and Curves, histograms and file formats, all help
create a barrier that can seem a difficult hurdle
to jump. But fear not; my aim in this book is to
break down those barriers in easy steps.

This book will take you through the process
of choosing the right gear so you can find
exactly what you need, it will detail the actual
business of photographing birds, and it will then
teach how to deal with your pictures once you
are home. To make life simple, the imaging
software used for Section 3 is the latest version
of Adobe Photoshop® (CS2 at the time of this
writing). Although there are a number of options
to choose from when processing digital images,
Photoshop is the clear market leader and the
most advanced application available. If you use
Photoshop Elements, nearly all the processes
described for the full version can be made in
Elements using the same tools.

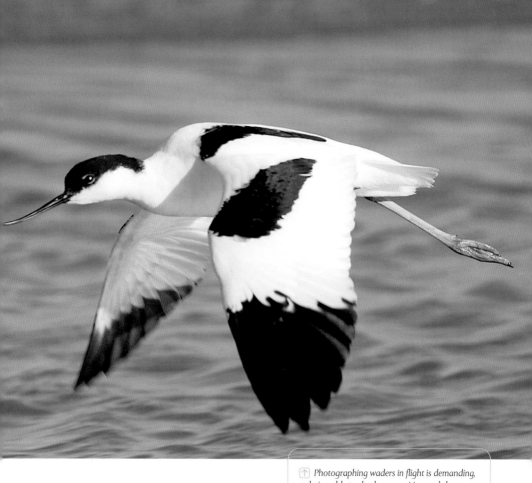

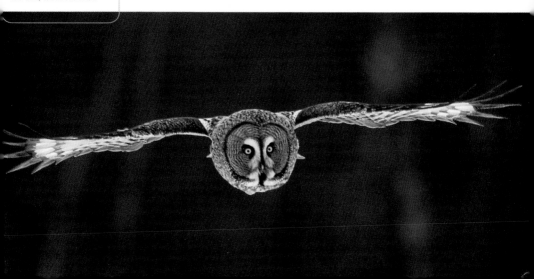

⬆ *Photographing waders in flight is demanding, so being able to check composition and sharpness as you shoot is a great improvement on the old film approach. This avocet was one of a number of successful flight shots taken in spring from one of the public blinds at Minsmere in Suffolk, U.K.*

500mm lens; ISO 100; 1/1000 sec at f/5.6

⬇ *After a long wait this great gray owl floated out of a dark Finnish forest straight toward me and my camera.*

500mm lens, handheld;
ISO 200, 1/500 sec at f/4

Why digital photography?

If you shoot digitally already, you probably don't need this question answered. However, if you are taking up photography and deciding between digital and film, or thinking of swapping from film to digital, then here are a few reasons to convince you that the digital format is the future of bird photography, simply because it provides so many more opportunities than a film-based approach.

Perhaps the greatest argument for using digital photography is the instant access to your image, allowing you to fine-tune as you photograph. Getting exposures right was a big bugbear with film photographers. Now, by using the controls on your camera, an exposure can be perfected as you shoot by viewing the images on the back of your camera to decide whether you like the composition or not. This ability to immediately view what you have taken gives instant gratification. No more long waits for films to come back from the lab.

Once you connect your camera to the computer, you can edit, delete, enhance, and make prints from your images—all within minutes or hours of having taken the photograph.

Many digital SLRs have cropped sensors (see page 16) that, in effect, act as extra magnification, bringing wary birds closer to the camera. Added flexibility comes in the form of being able to change film speeds between shots, and because a digital sensor is far more sensitive to light than film, it is much easier to capture dramatic action using faster shutter speeds and plenty of depth of field.

> *You can create arresting images of birds with the simplest of equipment—your imagination is the most important ingredient. This bald eagle on the beach at Homer in Alaska's Kachemak Bay was photographed laying on the wet sand to gain this intimate view.*
>
> 17–35mm zoom lens; ISO 100; 1/125 sec at f/8

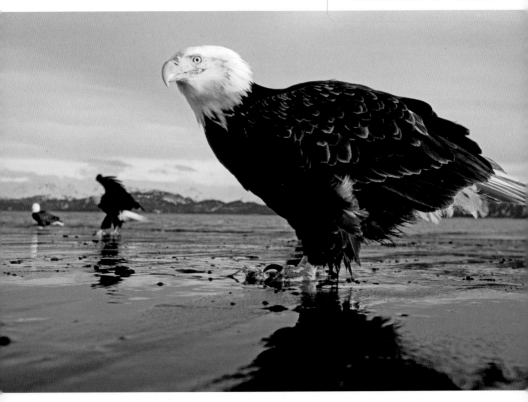

Running costs are another big factor in digital photography's increasing success. While a good system may not be cheap to set up, once you have all the equipment necessary, you can take as many pictures as you like without worrying about film and processing costs. Pictures in the digital format are easy to share with friends and post on the World Wide Web, and they can be printed with little fuss.

⬇ *Puffin among thrift, photographed in Scotland.*

600mm lens; ISO 100; 1/500 sec at f/5.6

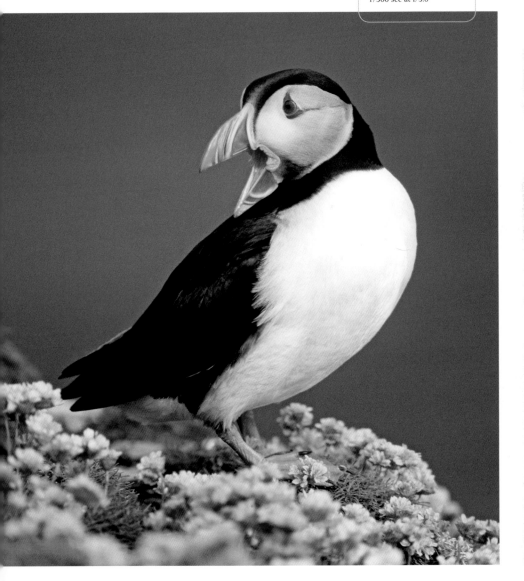

SECTION I

Equipment

While you will hear many declare it is not the equipment you use but the person behind the camera that produces great bird photographs, it is also true that you do need the right tools for this job. However artistic you might be, and however good your field craft, without the right camera and lens you will find yourself at an immediate disadvantage.

You do not need a vast arsenal of lenses to cover all eventualities. My camera bag contains three lenses that I use 95 percent of the time: a short focal-length zoom of 17–35mm, a medium telephoto zoom of 70–200mm, and a long telephoto 500mm lens. The lens dictates the style of the picture and how close you need to get to your subject, while the camera body you choose is simply the box that captures and stores your image.

Choosing equipment if you are new to photography can seem a confusing task. Like computers, digital SLRs are continually evolving and can become outdated quite quickly. The important consideration is to buy into a system that offers both flexibility for lens choice and the latest technology. The well-trodden path is to choose products from one of the major manufacturers, and I would recommend Canon or Nikon, since no other brand comes close to these for offering the same range of lenses desirable for bird photography and digital camera technology that is upgraded regularly.

The good news when buying equipment is that there are many retailers out there competing for your business. Shop around, particularly on the Internet, and don't accept the published prices retailers advertise; if buying a complete outfit, good deals can be struck by haggling and playing retailers against each other. Don't dismiss buying secondhand gear: there is a big market for used cameras and lenses, and most photographers do look after their equipment. Buying a secondhand digital camera from a private seller without the ability to fully test it might be risky, but lenses can easily be inspected before purchasing. Most dealers will provide insurance on secondhand equipment in the case of a fault being discovered.

← *If you cannot afford to buy a long telephoto lens right away, there are plenty of opportunities for using short lenses. This Atlantic puffin was photographed with my 70–200mm zoom.*

70–200mm lens; ISO 200; 1/640 sec at f/5.6

THERE IS AN EVER-INCREASING AND BEWILDERING RANGE OF DIGITAL CAMERAS AVAILABLE.
TAKE TIME TO FIND OUT WHICH IS BEST FOR YOU, IN TERMS OF BOTH YOUR PHOTOGRAPHY
NEEDS AND YOUR BUDGET, AND BE PREPARED TO SHOP AROUND.

What digital camera do I need?

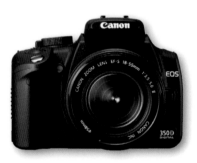

← *This Canon Digital IXUS 400 is a typical compact camera, and these are suitable for digiscoping. A digital single lens reflex (DSLR), like this Canon EOS 350D shown below, gives far more flexibility for photographing birds.*

Digital cameras can be divided into compacts—those commonly used by the general population for taking pictures on vacation—and digital single lens reflexes (DSLRs). The latter is used by more serious photographers, including professionals, and is the camera of choice for bird photography.

The reasons for this are clear cut. A DSLR allows you to interchange lenses and most importantly is backed up by a good choice of long telephoto lenses, a necessity for bird photography. When you look through the viewfinder of a DSLR, what you see in the frame is the actual view through the lens; further, you have the ability to check on depth of field (how much of the scene is in focus), and you can easily adjust settings for creating effects, whether you want to freeze action, blur motion, or control the depth of field.

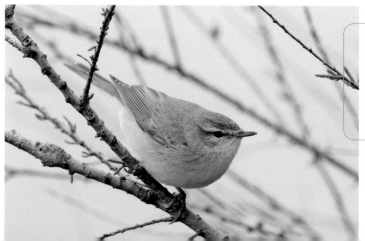

← *Digital SLRs allow the use of long lenses, so you can capture small, active birds such as this willow warbler on migration in southern France.*

500mm lens; ISO 200; 1/250 sec at f/4

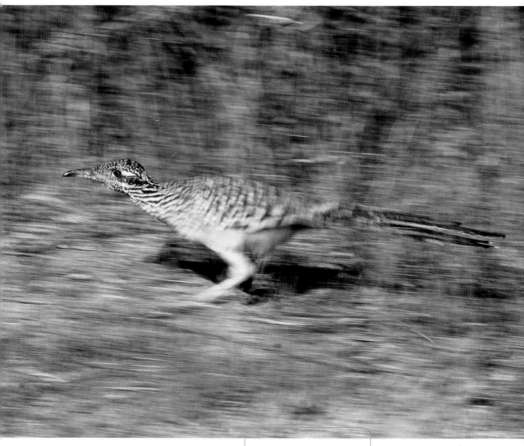

The flexibility of DSLRs means more possibilities for creativity. I used a slow shutter speed to create motion blur when photographing this greater roadrunner in New Mexico.

500mm lens: ISO 100; 1/30 sec at f/16

Digital compact cameras are far more limited; you cannot change their lenses, and although many have zoom lenses, these are not long enough for photographing most birds. Furthermore, they do not deliver the image quality of DSLRs. Even though many can match a DSLR for the number of pixels on the sensors, there is less processing power in the form of electronic circuitry.

The exception to the limitations of the compact digital camera in bird photography is its use for digiscoping (see page 18), where a compact camera is married with a telescope to take high-magnification images.

The Nikon Coolpix range of cameras dominates the digiscoping world; their lens design helps avoid vignetting (dark corners), and internal focusing avoids external movement of the lens, making these cameras ideal to use with the specialized adapters that attach to a telescope. Another plus with the Coolpix range is the camera design of the lens in one half of the body and the camera's hardware in the other. This means one half of the body can physically rotate, allowing the monitor to be angled so it is comfortable to view when lining up and taking pictures. Having said all this, there are other compacts suitable for this pursuit, with new models coming on the market all the time.

EVEN WHEN YOU'VE DECIDED ON A DSLR OVER ANOTHER TYPE OF CAMERA, THERE ARE A NUMBER OF OPTIONS TO BE EXPLORED BEFORE MAKING YOUR FINAL CHOICE. FOR SUCCESSFUL BIRD PHOTOGRAPHY, SOME OF THE AVAILABLE FEATURES NEED TO MEET HIGH STANDARDS.

Digital SLRs

Digital SLRs look and feel just like SLR film cameras. Where the film would normally be placed sits a sensor that records the image when you fire the shutter. Once it has captured your image, the sensor sends the digital information to a buffer, where it is processed before being stored on a memory card.

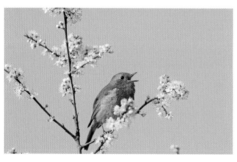

Sensors in DSLRs come in two formats: they are either the same size as a 35mm frame and are known as "full frame," or they come in a smaller size (the most common) and are known as "cropped sensors." Full-frame sensors are restricted to cameras with lots of pixels, generall ten million or more, while cameras with cropped sensors range from around four million to arounc twelve million pixels.

Because these smaller sensors have a cropping effect, they give the result of using a longer lens than in reality: for example, a 500mr lens when used with a camera that gives an effective 750mm zoom has a cropped frame to the factor of 1.5x. This is obviously a huge advantage to the bird photographer, particularly when working with small birds or those that are hard to approach.

⬅ *These pictures show how the cropping effect works in reality. The first image shows the effect of the robin photographed with a full-frame sensor; the second and third show the effect with cropped sensors—1.3 x and 1.6 x respectively. The robin was photographed in spring in the U.K.*

500mm lens; ISO 100; 1/500 sec at f/6.3

When choosing a DSLR body, there are a number of considerations to take into account:

How many pixels does the camera produce?

Pixels are the building blocks of an image—the more pixels a sensor has, the higher the resolution, and the more detail that will be recorded; this in turn affects how much you can enlarge the image. For example, a camera that produces eight million pixels will allow excellent prints of tabloid size and larger to be made, while a camera with 12 million pixels is good enough for just about any purpose. The other advantage of having a lot of pixels is that you can crop a picture more without losing a lot of quality.

❷ How many frames per second?

Birds are often in motion; feeding, fighting, bathing, flying. To capture action, it is a big advantage to be able to shoot pictures in quick succession, and achieving at least four or five frames per second is desirable. If there are fewer than that, you will miss potential shots.

❸ What is the burst depth?

This is the number of frames your camera will shoot before the buffer fills up and the camera prevents you from taking any more pictures until the buffer starts to empty. Digital cameras process a lot of information, and the more pixels you have, the longer your camera may take to process this information. The burst depth varies between makes of camera, and as technology improves it is becoming less of an issue.

⬇ *Capturing action successfully, such as this graylag goose's landing at Caerlaverock in Scotland, requires a digital SLR with a good burst rate and burst depth. This means you can capture as many images as possible as you follow the bird.*

500mm lens; ISO 100; 1/1000 sec at f/4

While the above points are important, so too is how the camera feels in your hand. When you use it with a long telephoto lens on a tripod, does it feel balanced? Are the controls readily accessible? Is it comfortable to look through the viewfinder? These are factors not to be ignored.

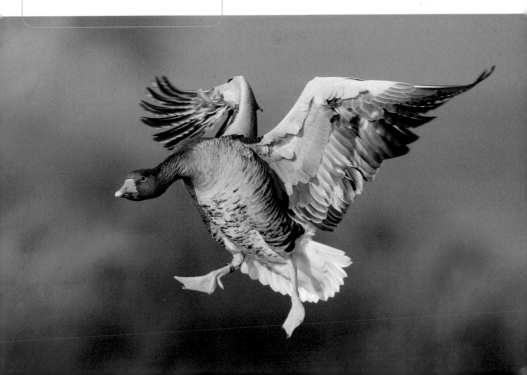

COMPACT DIGITAL CAMERAS REALLY COME INTO THEIR OWN IN DIGISCOPING, WHICH ENABLES EXTRAORDINARY CLOSE-UPS OF BIRDS TO BE CAPTURED. IF YOU DO DECIDE TO BUY A COMPACT FOR THIS REASON, MAKE SURE THAT THE ZOOM OFFERED IS OPTICAL, NOT DIGITAL.

Digiscoping equipment

Digiscoping is a recent phenomenon that has brought bird photography to the masses. Simply, it is the marriage of either a compact camera or DSLR to a telescope, of the type commonly used by birdwatchers, to take pictures. Bird magazines are now packed with images taken by this method. For many it is a stepping-stone to serious bird photography, while others find that it allows them to grab pictures of particular birds when out birdwatching.

Digiscoping started when birdwatchers began to experiment with placing their compact cameras against the eyepiece of their telescope when focused on a perched bird. Remarkable results were achieved, and the craze has now led to custom adapter mounts being manufactured to fix compact cameras and DSLRs to the scope. Of course, holding a compact to the scope's eyepiece still works, but by using a special adapter, more control can be gained over the focusing and composing of the image.

To go digiscoping you need a compact camera and as already discussed on page 15, the Nikon Coolpix range is one of the best options in this field. You also need a good-quality telescope with an eyepiece between 20–30x. The scope

← Digiscoping is very popular with birdwatchers wanting to capture images of vagrant birds, such as this laughing gull sporting its winter plumage. The gull is an American species photographed in Greece.

Nikon Coolpix 9500 on Nikon Fieldscope ED 82 with 22x eyepiece; ISO 400; 1/250 sec at f/8

⬅ Because of the high magnifications involved in digiscoping, you will find it takes time to get used to locating the bird in the camera's viewfinder quickly. I make it a habit to keep the lens at its shortest focal length when searching, only zooming in when I have the bird in sight.

eally should have a large objective lens of least 77mm—high-definition glass will help ormously—and this all needs to be mounted on tripod. Finally, get yourself a remote release lead, hich will help to avoid camera shake when using ry high magnifications or slower shutter speeds.

You can just hold any old compact up to the epiece of your scope and get very acceptable sults; however, for more control over your cture-taking, using an adapter is recommended. dapters fit between the camera and telescope epiece, usually by being screwed into the mera's lens filter thread. The image may ot always be very bright, but using a low- agnification eyepiece—ideally nothing larger an 30x—on your scope helps. These also ssist in both finding the bird and avoiding too uch lens shake, and most low-magnification epieces give ample power. One point to member when choosing a compact camera is ensure that the front lens element is smaller an your telescope's eyepiece, otherwise gnetting will be a big problem.

When choosing a compact camera, don't get fooled by the difference between optical zoom and digital zoom—the latter just zooms in on the image, enlarging the picture by sacrificing quality. Go for a camera with an optical zoom; this is a true zoom in that pixels are not sacrificed, and it helps eliminate or reduce vignetting. Even on low zoom settings, the magnification is far beyond anything possible with conventional telephoto lenses—for example, a 4x zoom combined with a 30x eyepiece will give a magnification of 90x.

There are adaptors for using DSLRs on telescopes, but limitations in image quality start to become apparent when using these, as the DSLR's superior picture quality shows up lens imperfections more easily. That said, such a setup is easier to use than a compact, since there is no shutter lag (delay in shutter firing) as found on some compacts, and it is easier to frame the image and focus when looking through a DSLR viewfinder.

⮕ The Nikon Coolpix 9500 and Nikon Fieldscope ED 82 are a typical digiscoping outfit. The Nikon Coolpix is fitted to a bracket that slips onto the eyepiece of the scope. This bracket allows for the zoom lens that extends from the camera when zoomed.

TELEPHOTO LENSES COME IN A VARIETY OF SIZES, RANGING IN PRICE FROM BUDGET TO VERY EXPENSIVE. A GOOD LENS IS ESSENTIAL FOR BIRD PHOTOGRAPHY, AND AN ADDED FACTOR IS THE APERTURE THAT COMES WITH THE LENS; SMALLER IS BETTER.

Telephoto lenses

Many of the birds you set out to photograph will be small, and even the few exceptions such as herons and other large waders appear to be surprisingly small when it comes to getting a decent photograph. When I'm out with my big 500mm lens, I regularly get comments from passersby to the effect that I must be getting a great shot of the bird's eyeball! In truth, however, to get a tight shot of even a relatively large bird like a duck, you need to be not much farther than twenty feet away with a 500mm lens.

⬆ *Great gray shrikes are notoriously difficult to get close to. For this image I had to resort to using a 1.4x converter on my 500mm lens. The image was taken at Lake Kerkini in Greece in winter.*

500mm lens; 1.4x converter; ISO 200; 1/320 sec at f/5.6

Having a long telephoto lens for bird photography is essential, and I suggest you need at least 400mm. There are photographers who favor 300mm lenses and use teleconverters (see page 24), and if you do a lot of general wildlife photography, this may be a sensible option; however, if birds are your main quarry, 500mm lens is the optimum length. There are a number of reasons for this: longer lenses tend to be substantially heavier and more bulky, so they end up being a real chore to carry when out in the field; they also come with a much higher price tag. A decent 500mm lens, although expensive, will give you the reach for all situations, including small birds such as warblers. When used with a cropped DSLR, you are, although this is not technically correct, in effect extending your focal length. Top-of-the-line 500mm lenses come with a maximum aperture of f/4; this wide aperture allows plenty of light in, making the lens easy to focus, and the autofocus is snappier when compared to a cheaper lens with a maximum aperture of, say, f/5.6.

⬅ *This image of a juvenile wood sandpiper taking off from a pool in Finland was photographed at 4 a.m. My f/4 lens gave me a little extra light to help freeze the action.*

500mm lens; ISO 200; 1/250 sec at f/4

There are advantages of going for a aximum aperture of f/4 over f/5.6, although is is only one stop. These are that you not only ᵉt better autofocus performance but also the ᵉway to use reasonably high shutter speeds at e start and end of the day, when the light is at best. In addition, this aperture gives the ability use a 1.4x converter for extra reach with small rds, while only losing one stop of light.

There are really plenty of options, even ithout choosing a 500mm lens. This is ᵃrticularly true when employing the use of ᵗeleconverters. Because many digital camera ᵒdies give a cropping effect, you might find ᵒme of these lenses adequate for your ᵗotography. A 400mm lens used in conjunction ith a camera with a 1.3x crop is going to give ᵒu an effective focal length of 520mm, while

a 300mm with the same crop becomes a 390mm lens. Good 300mm f/4 lenses can be bought for a fraction of the price of the bigger lenses, and a 1.4x teleconverter with a cropped frame camera might be the budget answer.

PRO TIP

When purchasing a telephoto lens, pay close attention to the minimum focusing distance of various models. You might think that this is immaterial with a 500 or 600mm lens; however, remember that goldcrests, kinglets, and tiny hummingbirds are actually very small. Even at the minimum focusing distance of my top-notch 500mm lens, such birds are still quite small in the frame.

ZOOM LENSES ARE A USEFUL ADDITION TO YOUR CAMERA BAG, AND AS WITH TELEPHOTO LENSES, YOU GET WHAT YOU PAY FOR WHEN IT COMES TO SPEED AND THE QUALITY OF THE OPTICS. ZOOMS ARE VERY VERSATILE, PARTICULARLY IN SITUATIONS WHERE YOU ENCOUNTER BIRDS THAT ARE TAME.

Zoom lenses

Medium-range telephoto zoom lenses are very useful for bird photography. There are many destinations around the world, such as Florida and the Antarctic, where the birds are so tame that many species can be photographed with a focal length much shorter than 400 or 500mm.

⬇ Zooms are very usef
as long as you can get fa
enough away from the
birds! This inquisitive kin
penguin was inspecting
Canon 100–400mm zoo
photographed on the isle
of South Georgia.

300mm lens; ISO 100;
1/250 sec at f/5.6

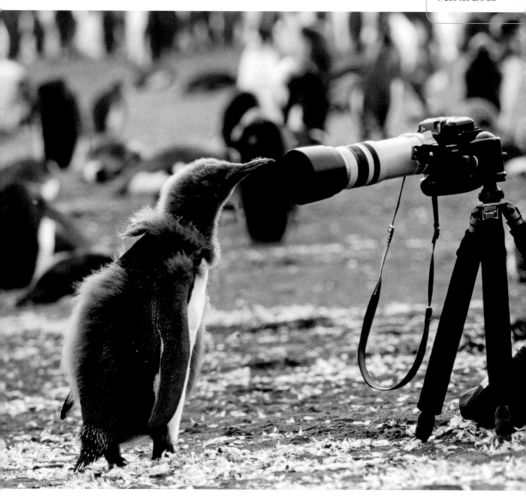

⬆ *If you want to sell
your work, then good
images of birdwatchers
are always in demand. I
use my medium zoom lens
for much of this work.*

70–200mm zoom lens;
ISO 100; 1/250 sec at f/11

⬆ *Medium-length zoom lenses can be really useful
for flight photography. I used a 70–200mm zoom
at 82mm to capture this parasitic jaeger in flight on
Scotland's Shetland Isles in spring.*

70–200mm zoom; ISO 100; 1/800 sec at f/5.6

e most popular medium telephoto zoom is the
0– or 80–200mm, which is ideal for all sorts
applications. I carry a 70–200mm lens in my
ag as a matter of course and use it regularly,
hether for birdscapes or closer shots of tame
bjects. The maximum aperture is normally
2.8, which is very useful in low light and for
king advantage of a very shallow depth of field
r close-ups with impact.

The shorter zooms, for example 55–120mm
nd 70–200mm, are ideal for what I call
rdscapes—landscapes that include flocks or
dividual birds. Such images can set a scene
eautifully, and some sites lend themselves
ell to this kind of image; for example the
inter flocks of snow and Ross's geese and
ndhill cranes in Bosque Del Apache in New
exico. Here you can stand on observation decks
verlooking both roosting ponds and feeding

areas, from where some really eye-catching
images can be made within the landscape.

There are plenty of other medium telephoto
zooms on the market, such as 75–400mm,
100–400mm, 100–300mm, and so on. The
disadvantages of some of these are their variable
apertures: for example, a 100–300mm may
have a maximum aperture of f/4 at the 100mm
range, but this may decrease to f/5.6 at the
300mm range. The advantage of these, however,
is in their cost, as they are normally a lot more
affordable than the fast f/2.8 lenses.

The price of a new fast lens may be
prohibitive, so don't dismiss buying secondhand.
Because of their popularity, there are always a
few available, and not only are you likely to save
yourself a lot of money but there is also a lot less
to go wrong in a lens than in a camera body, so
the risk of the equipment failing is much less.

Teleconverters

Teleconverters act as magnifiers that fit between the camera and the lens. Photographers give these all sorts of names, "converters" being the most commonly used. They normally come as either 1.4x or 2x, although Nikon makes a 1.7x version as well. In effect, you are multiplying the focal length of your lens by a factor of two when you use a 2x, so 500mm becomes 1000mm and so on.

The catch with converters is that the loss of light slows the lens down. When a 1.4x converter is used, you lose one stop of light, so your f/4 lens becomes a f/5.6; and with a 2x you lose two stops, so it becomes an f/8. This increase in focal length means you need to remember to use a fast enough shutter speed to avoid camera shake.

I often use my 1.4x converter but rarely my 2x, and there is a good reason for this. The doubling of magnification that a 2x brings means a much faster shutter speed is required to avoid camera shake, but because you have already lost two stops of light, you may find that unless the conditions are bright you will start to struggle with speed, having a decent tripod then becomes indispensable. Of course you can increase the ISO for optimum picture quality, but you should always lean toward using as low an ISO as possible to reduce the amount of noise in your image (see page 34).

Autofocus will be slowed down with converters, quite drastically with a 2x but less so with the 1.4x. This is because of the reduction in light, which affects performance. Some zoom lenses can struggle with picture quality when coupled with converters, although this is not noticeable when using the top-of-the-range

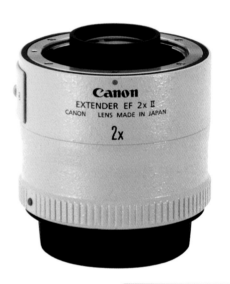

⬆ *Teleconverters are small lenses that further magnify the image found by your telephoto or zoom lens. This is the Canon Extender EF 2X II.*

lenses. I have used a 1.4x on my 70–200mm zoom to great effect, as this makes for a really useful combination for handheld flight shots.

You should always use the dedicated converters produced by your lens manufacturer;

→ *The goldcrest is Europe's smallest bird. Even at the closest focusing point for my 500mm lens, the bird still appeared quite small in the frame. By adding a 1.4x converter, I was able to boost the image size without having to crop too drastically once the image was on my computer screen.*

500mm lens; ISO 320; 1/320 sec at f/4

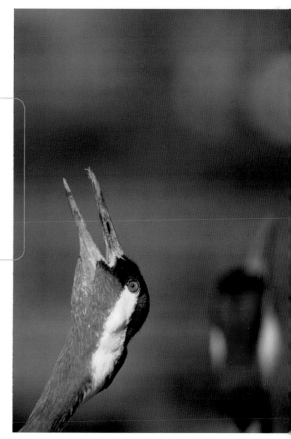

→ *This common crane, photographed in Sweden, started to call with another bird farther back. By using a 1.4x converter I was able to frame the closest bird, so that the one farther away appeared to be a mirrored reflection.*

500mm lens with 1.4x converter; ISO 100; 1/500 sec at f/4

hose produced by Canon or Nikon have the best lass and optical coatings to give an optimum esult. Independent lens manufacturers make onverters, but these are generally pretty awful n comparison, and you are likely to see a big rop-off in the image quality of your photographs. he same, however, is true if you use a top-class onverter on a cheap lens: the results will just ot be as you had hoped.

A WIDE-ANGLE LENS PROVIDES THE BIRD PHOTOGRAPHER WITH ANOTHER OPTION, THAT OF PLACING THE SUBJECT IN CONTEXT, AS OPPOSED TO FILLING THE FRAME. EXTREME WIDE-ANGLE LENSES, SUCH AS FISH-EYES, CAN BE USED VERY CREATIVELY TO MAKE UNUSUAL IMAGES.

Wide-angle lenses

You might think wide-angle lenses are superfluous to bird photography. Well, think again. Wide-angle lenses can be used to great effect in creating really eye-catching bird portraits, particularly with superwide or fish-eye lenses. The obvious use of a wide-angle lens is to photograph a bird within a wider scene—and this can add an interesting narrative. What I like to do, especially with fish-eye lenses, is to lure a bird so close to the lens that it is almost touching; this distorts the head a little and makes for a shot full of impact.

There are bound to be locations close to where you live where some birds are extremely tame. The obvious examples are parks in towns and cities: those with ponds and lakes almost always have tame waterfowl in them. The great thing about such places is the birds' readiness to come close when food is waved in front of their beaks. For example, St. James's Park in central London is a great place for bird photography, especially for taking wide-angle shots.

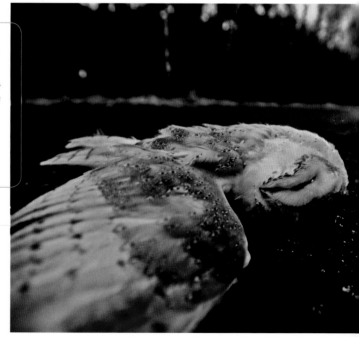

→ Wide angles can be utilized for a variety of shots. Here this road casualty barn owl made a strong foreground, giving the image impact. The car headlights in the background add drama and help to tell the story. I rested my camera on a beanbag for stability.

17mm lens; ISO 100; 1/45 sec at f/5.6

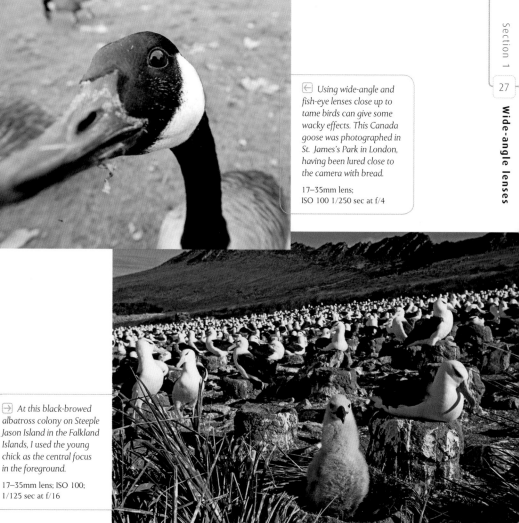

← *Using wide-angle and fish-eye lenses close up to tame birds can give some wacky effects. This Canada goose was photographed in St. James's Park in London, having been lured close to the camera with bread.*

17–35mm lens;
ISO 100 1/250 sec at f/4

→ *At this black-browed albatross colony on Steeple Jason Island in the Falkland Islands, I used the young chick as the central focus in the foreground.*

17–35mm lens; ISO 100;
1/125 sec at f/16

The closer your wide-angle lens focuses he better: the ideal length for creating images 24mm or less—more than this and you lose he effect. I use a 10.5mm fish-eye lens on a ropped-frame DSLR, which gives a fullframe quivalent focal length of around 16mm.

There are some great worldwide locations for sing wide-angle lenses to place a bird within he landscape; these include Antarctica, where ast penguin colonies extend almost as far as the ye can see. Often such pictures of colonies lack oreground interest, so whenever I am taking a

picture of a colony, I try and seek out a bird in the front of the pack, to use for impact in the foreground. This helps lead the eye into the picture and can also encourage a sense of scale. I have even used wide angles when photographing very tame bald eagles in Homer, Alaska.

It is often very easy to get caught up in using your long lens exclusively on a subject, but by stepping back and looking at the wider picture, a wide-angle might be just the job to take a really creative image of the bird within its habitat.

AS A BIRD PHOTOGRAPHER WHO WORKS ALMOST EXCLUSIVELY OUTDOORS AND IN
ALL WEATHER CONDITIONS, YOU ARE GOING TO NEED A TRIPOD THAT CAN BE CARRIED
EASILY AND WILL STAND UP TO A LOT OF HEAVY USE. IT MUST ALSO STAND FIRM ON
UNEVEN TERRAIN.

Tripods

**When using long telephoto lenses, it is essential you use a tripod.
Really the only time it is possible to get away with hand-holding
these is when taking flight shots with a high shutter speed.**

The stability of your tripod is key to the quality
of your pictures. You can spend thousands on
cameras and telephoto lenses, but if you then try
to save with a cheap tripod, it will only prove to
be a false economy. A good number of models
found in your average camera store are often
of poor design and do not last long when used
by outdoor photographers—who punish their
equipment rather more than someone operating
in a studio. When considering a tripod, give it

the wobble test: if it seems flimsy, then it
definitely will be no good for supporting a
heavy 500mm lens.

There are two manufacturers who stand
above the rest for making good, sturdy tripods;
they are Manfrotto and Gitzo, and they both offer
aluminum and carbon-fiber versions. Clearly a

> ⬇ *Using a sturdy tripod with a long lens pays
> dividends in poor light and adverse weather.
> Note the lens cover to protect against the snow.*

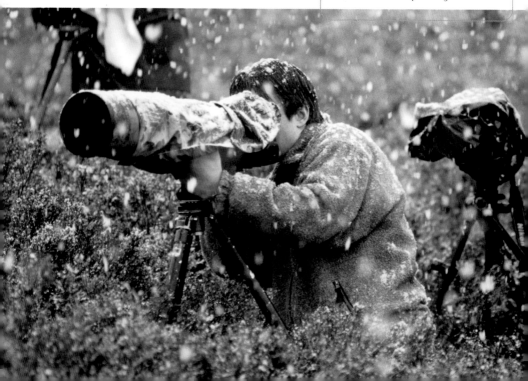

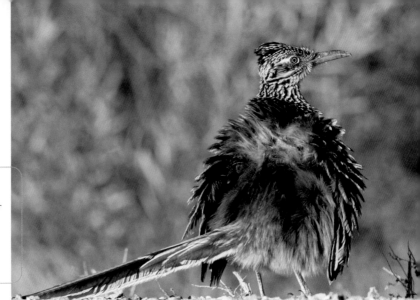

→ I used my tripod with legs splayed to capture this low-level portrait of a greater roadrunner sunning itself in New Mexico's Bosque Del Apache Reserve.

500mm lens; ISO 100; 1/250 sec at f/11

[car]bon-fiber tripod is going to be relatively light [w]hen compared to its metal cousin, but if you [de]cide to go for a carbon-fiber model, make sure [it] is not too light—if it blows around in the wind [it] will be useless. The only other drawback with [ca]rbon-fiber tripods is the cost: they are usually [tw]ice the price of metal tripods, so you need to [co]nsider the weight advantages versus cost.

I use aluminum Gitzo tripods, which are a [fa]vorite with professionals due to their durability: [w]ell-made, well-designed, and easy to operate, [th]ey are hard to fault. My recommendation is [to] go for a model with no central column, since [su]ch columns create wobble when extended. It [is] also a good idea to go for a model where the [le]gs will splay out at right angles, which is really [u]seful when on uneven ground or sitting on a [ba]nk, as you can make the tripod very stable by [se]tting just the right angle with your legs. With [sp]layed legs and no central column, you also [h]ave a good support for laying on the ground [an]d shooting low-level shots. Those tripods [w]ith the central column inverted or jutting out [si]deways are definitely worth avoiding, since they [co]mplicate what is a simple operation.

While on the subject of tripods, there is [on]e other device worthy of investigation for [oc]casional use, and that is the monopod. Using [ju]st one leg takes practice with a long lens, but

monopods are useful for stalking birds in thick bush, or for using medium telephoto lenses. They are not a substitute for a good tripod, but they are certainly better than using no support at all. As with tripod legs, they come in both aluminum and carbon fiber; the latter is best for monopods as all the weight is concentrated on the one leg, giving it stability despite its lack of weight.

↓ There are a wide variety of tripods on the market. The professional versions are much more adjustable, and those without a central column are more flexible. Regardless of which tripod you select, it should be robust enough for lasting stability.

→ If you enjoy the field-craft aspect of bird photography, consider using a monopod. These are easier to carry, quicker to use, and lighter, though less steady, than a tripod.

WITH A BASIC CHOICE OF FOUR TYPES OF TRIPOD HEAD, YOU MAY HAVE TO SPEND SOME
TIME IN CAMERA STORES, TRYING OUT DIFFERENT MODELS AND STYLES UNTIL YOU FIND
ONE THAT FEELS COMFORTABLE WITH YOUR TRIPOD, CAMERA, AND LENS.

Tripod heads

Once you have your tripod legs, you obviously need a head on
which to mount your camera and lens. Heads come in four basic
types: the gimbal-style head, pan-and-tilt, video or fluid head,
and the ball head. Unlike choosing a set of tripod legs, where
there is a clear definition of what is needed, which tripod head
you choose is a matter of personal choice. Test the head with
your tripod, camera, and lenses and go with the one that you
feel gives the most flexibility and stability for your setup.

In my career I have, at one time or another,
used all four kinds of tripod heads. For many
years I used a pan-and-tilt head, which
tilts backward and forward and swivels around,
all controlled by a series of knobs. Pan-and-
tilt heads are very easy to use and give good
stability to long lenses. When looking at these,
avoid those that have a long handle to control
the forward-and-back movement—these can be
very awkward, as they tend to stick into your
shoulder when looking through the viewfinder.

⬆ A ball head combines
a simple design with a large
amount of flexibility. The
circular knob adjusts the
mechanism's resistance
to cope with different lens
weights, and the opposite
lever fixes the camera
to any position on a
horizontal plane.

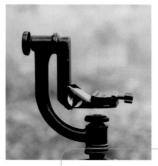

⬆ Both the Wimberley (left) and the new
Dietmar Nil (right) tripod heads are excellent for
action photography, allowing for smooth panning
and a stability not offered by more traditional
heads when using long lenses.

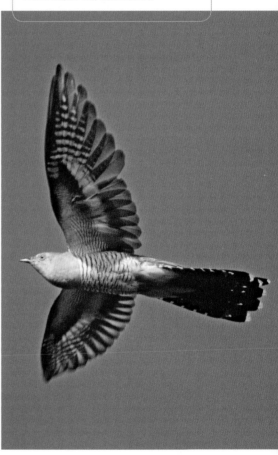

Video or fluid heads are similar in effect pan-and-tilt heads. They have very smooth tions, since the mechanism sits in a viscous id; others operate by using a system of springs. ey allow various settings for resistance, and e popular with filmmakers as well as stills otographers. The downside is their expense.

My head of choice is the ball-and-socket, mmonly referred to as "ball heads." These ve just one knob as a control, giving ease of ovement in any plane, with a control for setting sistance. They do take a bit of getting used to, t once mastered, they are very versatile. Arca viss is perhaps the best-known make and is a gh-quality name. Ball heads come in different es, so it is imperative to purchase one big ough to take your heaviest lens comfortably.

Finally we come to the gimbal-style heads. e most popular of these is the Wimberley, pecially with bird photographers in the United ates. It is ideal for long, heavy lenses such as e 500mm and the extra-large, heavy 600mm 4 models, as the large lump of glass in the end these has a tendency to tip the lens forward hen tension is loosened on other tripod heads.

The Wimberley works by allowing you to gn the center of gravity for the lens so that ns and camera are held in perfect balance. This eans the lens can pivot in the horizontal and rtical axes with little resistance, so it is great r following birds in flight. The downside is th price and weight. If you do a lot of walking hen out shooting bird pictures, the gimbal style ay prove too heavy. Remember also that it is one-trick pony, great for big telephotos, but t suitable for shorter lenses.

The alternative to the Wimberley is its baby other, the Sidekick, which has the advantage being small. It is an arm that fits onto a ball ad to give you a similar freedom of movement the Wimberley. The other advantage with this that you retain the ball head capability, which more useful for shooting other subjects with orter lenses.

⬇ *The Wimberley head is great for tracking birds in flight. I used one to capture this image of a European cuckoo in flight.*

500mm lens; ISO 100; 1/800 sec at f/8

Whatever system you choose, it is worth investing in quick-release plates. These attach to the lens and slip onto the tripod head, allowing a lens to be fixed or removed very quickly—this might make the difference between grabbing an unexpected shot or not.

A SIMPLE BEANBAG OR WINDOW MOUNT IS THE ANSWER FOR TAKING SHOTS WHILE
TRAVELING IN A VEHICLE, WHEN A TRIPOD IS IMPRACTICAL TO USE. BOTH HAVE
THE ADVANTAGE OF BEING LIGHT AND EASILY TRANSPORTABLE.

Beanbags and window mounts

Cheap and versatile, and an essential piece of your kit if you take
pictures when traveling, a beanbag is simply a cloth bag with a zip
that you can fill with dried beans or rice. I prefer rice, since it is easily
obtainable anywhere in the world. One trick some photographers have
is to fill it with bird seed, as you never know when this might come in
useful! Make sure that, whatever you use, the bag is filled sufficiently
to give good, solid support. Beanbags are ideal for use as supports on
window frames in vehicles or as a rest on the lip of a public blind, and
I often use them when lying on the ground to take low-level shots.

There are two types of beanbag you can buy, if
you decide to purchase rather than make one
yourself. They differ in that one is simply a bag,
while the other is a double-pocket design. The

latter flops conveniently over car window ledges
and the narrow space for the filling at the top
helps the bag not to sag. Make sure you buy or
with a zip so it can be emptied when traveling,

← Window mounts are
very useful if you take a lot
of pictures from your vehicle.

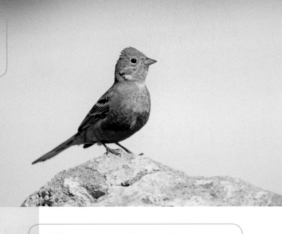

I photographed this Cretzchmar's bunting
[in] Greece resting my telephoto lens on a beanbag
[pla]ced on a rock.

[50]0mm lens; ISO 100; 1/800 sec at f/5.6

← Beanbags are flexible and ideal for photography
from vehicles; this image of a red grouse was one
such result.

500mm lens; ISO 125; 1/200 sec at f/4

Window mounts can also be very useful
if you do a lot of photography from public bird
blinds. The wooden blinds found on Royal Society
for the Protection of Birds (RSPB) reserves
in the U.K. often offer good opportunities for
photography, and window mounts are frequently
ideal for support when shooting from some of
these, particularly when seating arrangements
sometimes preclude the use of a tripod.

save on weight. As you're unlikely to be using
[m]ore than one large lens at a time, there's no
[n]eed to buy more than one beanbag.

As an alternative to using a beanbag as your
[su]pport in a car, there are specially designed
[w]indow clamps on the market. One of the best
[in] terms of design and engineering is the Kirk
[w]indow mount, made by Kirk Enterprises; the
[ad]vantage of this over some others is that
[yo]u can attach your tripod head to the mount.
[W]indow mounts have the edge on beanbags
[wh]en used in a vehicle moving away from
[th]e open road, as you can leave your camera
[an]d lens set up on the mount, ready for
[in]stant action.

PRO TIP

Use beanbags with your long lens to
add stability. As well as resting the lens
on the bag, rest another on top to prevent
any shaking. I have used this technique
in wooden blinds and when in a vehicle,
when using slow shutter speeds that create
motion blur.

EXPOSURE IS A COMBINATION OF LENS APERTURE, CAMERA SHUTTER SPEED, AND SENSOR SPEED. SUCH A MIX MAY SOUND COMPLICATED, BUT THERE ARE A FEW SIMPLE GROUND RULES THAT WHEN FOLLOWED SHOULD ENSURE SUCCESSFUL EXPOSURE FOR EACH SHOT.

Understanding exposure

What is a correct exposure? In effect, it is recording the bird in the way that you want, ensuring that detail is retained in the brightest and darkest areas. There are three things working in conjunction with each other that determine the exposure you use. They are the camera's shutter speed, lens aperture, and sensor sensitivity—expressed as an ISO value.

You will hear photographers talking in "stops" when discussing exposure—a stop is simply the term used to describe an increment, whether it is increasing or decreasing the amount of light being let through a lens.

The apertures marked on a lens are f-stop numbers and, on a lens of short focal length, typically range from f/2.8 to f/32. At f/2.8, the aperture on the lens is wide open, allowing the maximum amount of light to the camera's sensor, while at f/32 the lens aperture has just a small opening, letting little light in. When we want to let more light in, we use the term "opening up." When we want to decrease the amount of light coming in, we are "stopping down."

Each increase or decrease in the range either doubles or halves the amount of light being let through to your camera's sensor. For a lens with a typically large f-stop of f/2.8, the series would be f/2.8, f/4, f/5.6, f/8, f/11, f/16, f/22, f/32. These are standard one-stop increments.

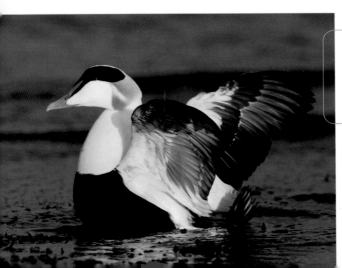

← Eiders are a favorite subject of mine. This common eider drake was photographed in northern England in the spring. When photographing birds with white tones in the plumage, take care to ensure detail is not blown.

500mm lens; ISO 100; 1/800 sec at f/5.6

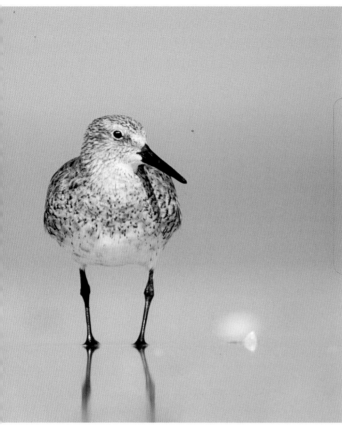

← *This image of a red knot was taken on a beach in Florida during the middle of the day. The surroundings were very bright, so to gain an accurate exposure quickly I used the spot-metering mode–taking a reading off the bird's breast. I also used an angled viewfinder on the camera.*

500mm lens; ISO 100; 1/1000 sec at f/8

↓ *This displaying great bustard needed plenty of depth of field and a fast shutter speed to freeze the bird's quivering movement.*

500mm lens; ISO 100; 1/500 sec at f/8

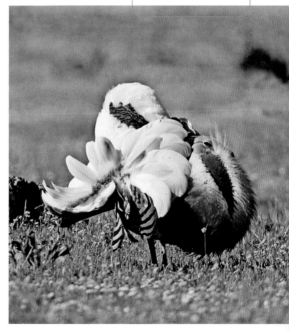

s you move up the scale, you are halving the
mount of light traveling through the lens by
djusting the size of the hole—or aperture.

The aperture's role in the creativity of a
hotograph is to control the depth of field. This is
e area in focus from the nearest to the farthest
oint in the picture. At f/2.8, the depth of field is
ry shallow, whereas at f/22 the background to
e subject is likely to be in reasonable focus.

The shutter in your camera normally opens
r a fraction of a second, and as with f-stops,
either halves or doubles the amount of light
tting the camera's sensor depending on which
ay you go with the scale. However, most
meras and lenses allow you to measure not in
hole stops but, if you so desire, in increments
one third of a stop. Typical camera shutter
eeds range from thirty seconds or longer to
4000 sec or even 1/8000 sec.

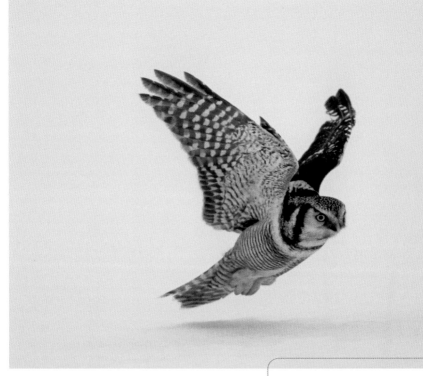

The ISO value is the final piece in the exposure jigsaw. ISO stands for International Standards Organization and traditionally describes film speeds, although a DSLR dictates the speed of your sensor. Typical DSLRs range from ISO 100 to 3200: the higher the rating, the more sensitive the sensor is to light. Higher ISO settings mean that less light is needed to make a picture, enabling images to be taken in poor light conditions, or with higher shutter speeds and smaller apertures.

The ISO rating you choose acts as the basis for your exposure. Higher ISO values in DSLRs come with drawbacks in the form of increased signal noise. Although not the same as "grain" in film, this has a similar effect in that the image is degraded. Signal noise normally starts to become apparent with ISO values of 400 and above. Having said this, there are some DSLRs that exhibit little signal noise at higher ISO settings, so this may not be an issue for you—experiment with your camera and see how it fares. Of course,

⬆ *Hawk owls fly extremely fast, so a very fast shutter speed is required to freeze them in midflight. On the day I took this image the light was very poor, so that to gain a shutter speed of 1/2000 sec I had to use a high ISO of 400.*

500mm lens; ISO 400; 1/2000 sec at f/4

in poor light a picture may only be possible with a high ISO, but to keep quality as high as possible, an ISO of between 100 and 200 is recommended in most situations.

Once your ISO value is set, the shutter speed and aperture are linked. Alter the value of one, and the value of the other has to be changed to provide a correct exposure. There is only ever one correct exposure, but many different combinations of shutter speed and aperture; this is known as "exposure ratio." If, for example your camera's meter tells you the correct exposure is 1/250 sec at f/8, and you decide you need a faster shutter speed of 1/500 sec, then by halving the amount of light coming into the lens to retain the correct exposure, the aperture needs to be opened up one stop to

5.6, thus allowing the same amount of light to your camera's sensor. Creating a picture is a balancing act of choosing the right aperture for the effect you want along with a high enough or low enough shutter speed.

On a typical DSLR there are three light-metering options to choose from. Matrix or multipattern metering takes information from across the picture to give a reading and is the most sophisticated of the three. It is fooled occasionally, but for much of the time it is very accurate. My preferred option is center-weighted metering, which takes a central area of the frame usually defined by a square or circle visible in the camera's viewfinder. Finally, there is spot metering, which is very useful for evaluating the exposure for a small area of the picture but should not be used all the time since readings will vary wildly within the picture, depending on where you point the camera.

PRO TIP

Whenever you can, use the lowest ISO setting your camera allows. This will reduce noise in your image. I rarely go above 200 ISO, and I normally try to shoot all my images at 100 ISO.

⬇ *For this image of a red-throated loon, I had to choose a fast enough shutter speed to freeze the action, but I also needed a large enough depth of field to ensure that the head and some of the body was kept in focus.*

500mm lens; ISO 320; 1/500 sec at f/8

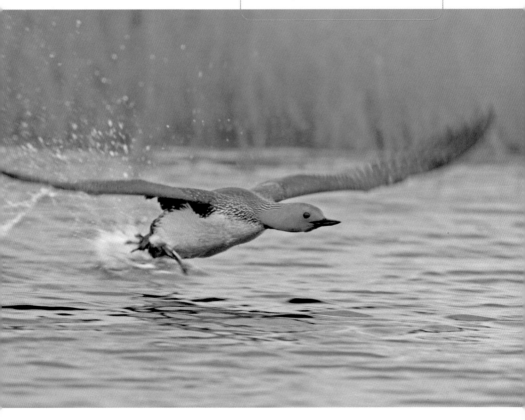

THE HISTOGRAM FUNCTION IS ONE OF THE DIGITAL CAMERA'S GREATEST ADVANTAGES OVER FILM, ALLOWING YOU TO CHECK FOR OVER- OR UNDEREXPOSURE ON THE SPOT AND THEN CORRECT IT, WITHOUT HAVING TO WAIT FOR A FILM TO COME BACK FROM THE LAB.

Exposing correctly using the histogram

The histogram displayed on the back of your camera is your primary tool for nailing a correct exposure. Ignore this and your exposures are likely to be wayward, leading to poor image quality.

It is tempting to use your camera's LCD screen image to visually assess whether your photograph will look right. This is a big mistake; for a start, the screen's brightness can be adjusted, and viewing conditions may also be far from ideal. Use the screen for looking at composition, and to roughly check sharpness, but do not rely on your screen for assessing exposure.

A DSLR's histogram maps out the brightness levels in an image, from black on the left to white on the right. The vertical axis shows the number of pixels for each level. In a well-exposed image, the range of brightness levels stretches across the histogram. If the histogram is bunched to the left, it is likely the image is underexposed, and if leaning to the right it may be overexposed.

Use the histogram to check that you are not clipping data at either end. Specular highlights, such as the sun or highly reflective surfaces can create a spike tight against the highlight end of the histogram. These cannot be helped, but blowing highlights that contain important details—such as in white plumage or snow, must be avoided, as these details cannot be retrieved in Photoshop. On these occasions it is better to slightly underexpose for whites, which at least can be restored.

Underexposing an image too much leads to noise (similar to grain in traditional photography) in dark and shadow areas, so it is important to expose as accurately as possible. A full exposure, or one that tips toward overexposure, will retain better detail, as more data is retained in highlights than in shadows; however, again care must be taken not to blow the highlights. The best way of checking for this, apart from just viewing the histogram, is to use the blinker function on your camera. This causes all the blown highlights to flash in the picture when viewed on the camera's LCD.

To sum up, it is better to have your histogram leaning toward the right but not clipped, rather than being bunched up to the left. However, if your subject and surroundings have a lot of light tones take care not to blow highlights and if necessary underexpose a little to retain detail. You can always rescue detail from underexposed parts of an image if not clipped, but never from blown highlights.

Histograms and your LCD can be difficult to see in bright conditions on some camera models, but you can buy specially adapted bellows to help with viewing. However, I can recommend a free alternative—a cardboard toilet-roll tube is ideal.

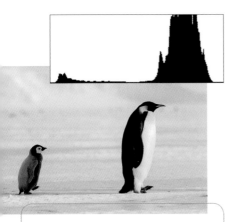

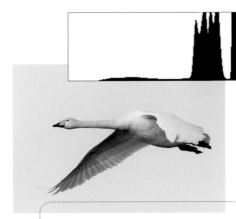

↑ In this image of an emperor penguin with chick, the snow, ice, and white breast of the penguin are represented by the majority of pixels being bunched to the right-hand side but not clipped. You can see the dark back and head of the penguin represented by the "mini mountain range" on the left. Care needs to be taken with pictures such as this, to ensure your histogram does not show any, or at least very little, clipping.

300mm lens; ISO 100; 1/500 sec at f/5.6

↑ The histogram for this flying whooper swan clearly shows the predominance of light tones, of both the sky and white plumage of the bird, by the pixels being grouped toward the right. Be careful that the peaks shown at the extreme edges of a histogram are not "clipped," or cut in half, as these images will probably show lost detail in the brightest or darkest areas.

500 mm lens, ISO 200, 1/500 sec at f/6.3

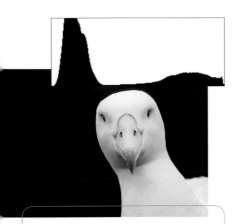

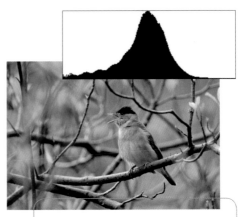

↑ Histograms can take on many different shapes. In this example there are mainly dark and light tones with just a few midtones, so the pixels are bunched at either end. I have gone for as correct an exposure as possible here, exposing the whites of the wandering albatross just about perfectly without clipping. I could have underexposed the whites to be safe, but this might have introduced distracting signal noise to the dark background.

500mm lens; ISO 100; 1/125 sec at f/11

↑ This correctly exposed image of a singing blackcap has many midtones within the image, so the majority of the pixels are in the middle of the histogram.

500mm lens; ISO 100; 1/500 sec at f/5.6

SOME OF THE MOST EXCITING AND DRAMATIC IMAGES OF BIRDS ARE TAKEN WHEN THEY ARE IN MOTION—FLYING, DIVING, SWIMMING, AND SO ON. BEING ABLE TO CAPTURE THIS ACTION MEANS USING FAST SHUTTER SPEEDS WHILE RETAINING SOME DEPTH OF FIELD.

Freezing action

Birds are, by their very nature, highly active creatures, and they are rarely still, whether they are feeding, fighting, courting, or flying. Capturing action, therefore, is a big part of bird photography. Digital cameras provide a good deal more opportunity for freezing motion in comparison to their old film counterparts. The higher sensitivity of a digital sensor compared to film means we can use faster shutter speeds to capture stills of behavior not seen before, since this style of working only existed in the limited domain of the high-speed specialist.

It is easy to underestimate the shutter speed required to freeze all movement in a small flying bird such as a wader. The bird might be flying at 30–40 mph and flapping its wings at a fast rate—such movement can normally need at least 1/1000 sec to avoid blur, and even then the wing tips might suffer a little. Generally, the smaller the bird the faster the shutter speed required to freeze movement.

A few years ago I had the opportunity to photograph a hunting hawk owl, which would appear in a tree above snow-covered pastures,

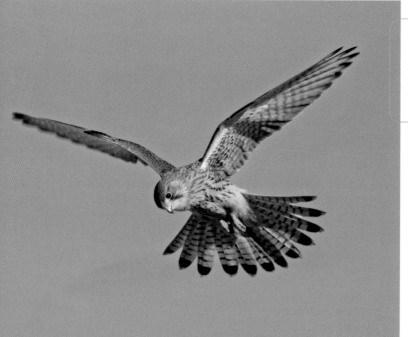

← A hovering kestrel requires a fast shutter speed to stop the rapid wing movement from blurring the image.

500mm lens; ISO 160; 1/750 sec at f/8

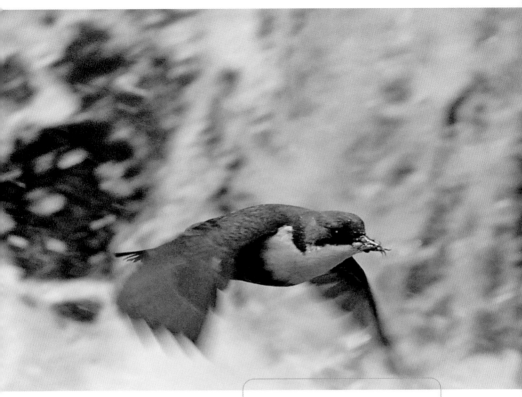

s it looked for movement above or below
e snow, largely preying on field voles. On
ccasions when it flew close, its speed of flight
as breathtaking, and I found that to freeze all
ovement I had to use 1/2000 sec; for many of
e images I took I used 1/4000 sec to ensure
e wing tips were pin sharp.

When shooting action, the desire is to use
e fastest shutter speed possible, but this may
ean having to use a wide aperture and shallow
epth of field. This can be quite a dilemma, but
ven slow shutter speeds, such as 1/60 sec, can
eeze a wing stretch if you take enough images.
asically, this will always be a balancing act;
eep in mind it is often better to have the key
arts of a bird in focus and risk movement rather
han having an out-of-focus element distracting
om your pin-sharp subject.

Useful action photography relies on you
aving some knowledge of your subject and
eing able to anticipate behavior. It is likely that
for most opportunities you will be using a long
focal-length lens; getting used to handling and
adjusting controls without having to take your
eye from the viewfinder takes practice, but is
essential if you are not to miss out on some
potentially great shots. Autofocus comes into
its own when tracking a running, swimming,
or flying bird, and when things start to happen,
take as many shots as possible. Keep an eye on
your buffer—it is important when shooting with
lower-priced DSLRs, which have fewer frames per
second and longer image-processing times, that
you don't shoot too early, lock the camera up,
and miss the peak of the action.

BLURRING MOTION USING SLOW SHUTTER SPEEDS CAN GIVE DRAMATIC EFFECTS. TRIAL AND ERROR WILL SHOW THE MOST APPROPRIATE SPEEDS FOR A PARTICULAR TYPE OF MOTION OR ACTION, BUT THERE ARE SOME RULES TO FOLLOW IN ORDER TO MAINTAIN IMAGE QUALITY.

Motion blur

Blurring motion has become somewhat de rigueur for wildlife photographers in recent years, since it is a great way of illustrating movement. Motion-blur images also have their detractors. For some people such pictures leave them cold, while for others a motion-blur image can be regarded as a real piece of art.

Motion blur brings a whole new dimension to bird photography in my view; with this technique pictures can resemble paintings, creating a mood and atmosphere in an image that may be lacking if the bird's motion had been frozen. Whenever I am shooting birds in flight or running, I am always assessing whether there is potential for motion blur to enhance the picture.

One of my favorite subjects is flamingos, which, because of their colorful plumage, provide excellent subjects for slow shutter speeds. On East Africa's Rift Valley lakes, lesser flamingos parade in groups up and down the shoreline in a courtship ritual that involves the shaking of head and fast walking. The image below was taken on the shores of Lake Nakuru, and to enhance the

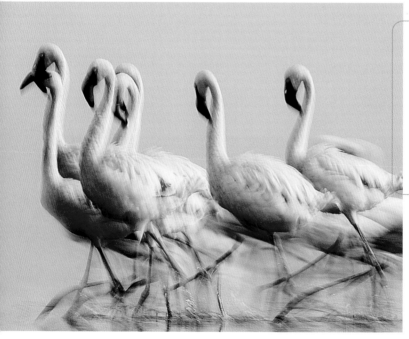

← A group of lesser flamingos rushes along the shore of Lake Nakuru in Kenya's Rift Valley. Although I took many conventional shots of this scene, those where motion blur was introduced by using a slow shutter speed have worked best.

500mm lens with angled viewfinder; ISO 100; 1/20 sec at f/32

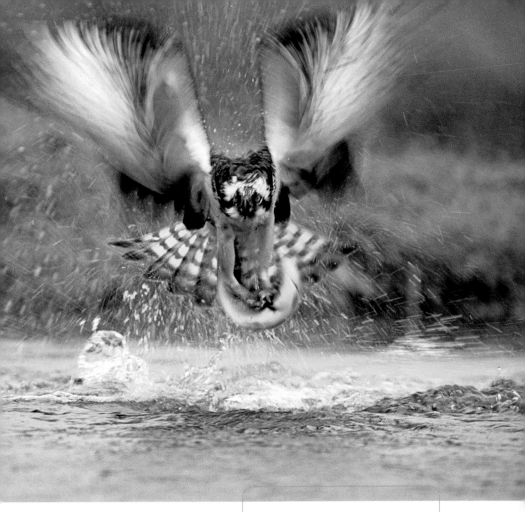

↑ *This osprey exploding from the water in Finland with a trout is one of my best-known motion-blur images. I used a beanbag laid on top of the lens to help keep the shot's action stable.*

300mm lens; ISO 100; 1/15 sec at f/16

ovement I used a shutter speed of 1/15 sec—
ny slower and the movement may have been
o much, making the birds indistinguishable; any
ster and too many sharp components may have
een visible in the picture, so losing the effect.

This illustrates how unpredictable capturing
otion-blur images is. As it is so hit-and-miss,
e effect you will get cannot be gauged in
dvance. To hedge your bets when taking a
equence, take as many images as possible, and
the action is repeating itself regularly, as with
e flamingos opposite, you can experiment with
utter speeds. I tend to find that speeds between
/8 sec and 1/30 sec work best, with around
/15 sec giving the most consistent results.

Image-stabilized lenses are great allies when
ooting motion-blur images, since they help

eliminate a lot of the camera shake that may
be inevitable when using long lenses at such
slow shutter speeds. These lenses help restrict
the blur to the faster-moving parts of the bird.
In many instances, having some sharpness to
the bird's head, or at least its eye region, is
desirable; if you have a very blurred head, a
lot of the impact and focus of the photograph
can be lost. A Wimberley tripod head (see page
30) is also useful, as it allows for a steady,
smooth panning action, helping to eliminate
shake from the lens.

ACCURATE CONTROL OF DEPTH OF FIELD IS A CRUCIAL ELEMENT IN CREATING THE PICTURES
YOU DESIRE. THE DEPTH-OF-FIELD PREVIEW BUTTON, A STANDARD FEATURE ON QUALITY
DIGITAL SLR CAMERAS, ALLOWS YOU TO CHECK AND ADJUST THE DEPTH OF FIELD BEFORE
TAKING A PHOTOGRAPH.

Understanding depth of field

The depth of field in an image is defined as the area in focus from
the nearest to farthest point, and it is controlled by the lens aperture.
Being able to control depth of field in your image is one of your most
important tools for creating the photograph's mood. For example,
with a 300mm lens wide open at f/2.8, the depth of field will be
very shallow, isolating the bird from its background. The same frame
photographed at f/22 will have a far greater depth of field, and the
background may be clearly visible. In short, the higher the f-stop
the greater the depth of field.

At any chosen aperture, the farther your subject
is from the camera the more your depth of field
increases; therefore, when birds are very close
you need to check that you have enough depth
of field for the entire bird to be sharp, if this is
what you desire. You do this by using a depth-
of-field preview button on your camera. This tool
is indispensible when choosing a DSLR, since

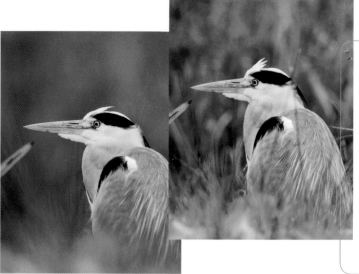

← These two images of a
gray heron's head illustrate
how a background can be
controlled by choosing an
aperture to give more or
less depth of field. The first
image was taken with an
aperture of f/4; this very
shallow depth of field throws
the messy background
into a soft wash of color so
attention can focus on the
bird. The second image
was taken with a large
depth of field–f/16 in this
case–which creates a
more untidy background
and foreground.

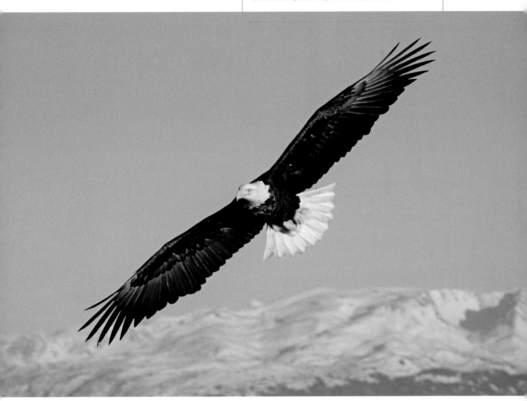

⊥ *I purposely wanted a large depth of field for this image of a soaring bald eagle, in order to illustrate the bird's habitat by showing the snow-capped mountains in the bottom of the frame.*

300mm lens; ISO 100; 1/250 sec at f/16

ithout one you will not be able to judge with ny accuracy where your nearest and farthest oints of focus are.

Most bird photographers aim to shoot with ie lens as wide open as possible as this allows r as fast a shutter speed as possible, but, more nportantly when using a long telephoto lens, it lso creates a pleasingly out-of-focus foreground nd background, thus placing attention on the ird. This is particularly helpful when birds are set gainst very messy or distracting backgrounds.

Using a shallow depth of field on birds ose up can offer opportunities for high-impact nages. The eye is nearly always going to be ie focal point in an image for a viewer, so you lould always aim to at least have this sharp.

There will be occasions when a large depth of field can give a real feel of sense of place, providing the viewer an opportunity to gaze upon the surrounding habitat in which the bird is placed.

Focusing on more than one bird can present you with a dilemma: do you go for maximum depth of field and try and get both birds? If you are focusing on a flock, do you try to get as many as possible sharp, or do you selectively focus on an individual and push the rest out of focus? If the birds are too close to put them cleanly out of focus, it is often best to try for a large depth of field and get as many as possible in focus, as birds that are just out of sharp focus in an image can be very distracting.

A FEW YEARS AGO, A GREAT MANY VARIETIES OF MEMORY CARD WERE AVAILABLE, BUT COMPACT FLASH IS THE MOST USED TODAY. ALTHOUGH THERE ARE THREE TYPES OF FILE FORMAT, YOU ARE ONLY LIKELY TO BE USING JPEG OR RAW FILES.

Memory cards and formats

A memory card, or "digital film" as it is often referred to, is the card your camera uses to store the images it processes. Just like a roll of film, the card is removed when full, and the images are transferred from card to computer using a USB card reader or the direct cable connection supplied with your camera.

← Launched in 1994, the CompactFlash card gives nonvolatile storage and can retain data without battery power. Typical capacities are 256Mb, 512Mb, 1Gb, 2Gb, 4Gb, and 8Gb.

Digital film comes in a variety of formats that include IBM Microdrives, Secure Digital (SD) cards, and CompactFlash (CF) cards. The vast majority of cameras likely to be used for wildlife photography take CF cards, which are the most widely used. They come with varying storage capacities, normally ranging from a few hundred megabytes (Mb) to up to 8 gigabytes (Gb). If you are a digiscoper shooting relatively small-sized JPEGs, you will only need to use small-capacity cards. The higher the capacity, the more expensive they are.

If you are a DSLR user and likely to be shooting in the RAW format (see page 48),

you will be able to fit far fewer pictures onto a card, so consider buying a high-capacity one. I currently use 4Gb cards, which take around 200 images when shooting in RAW; if shooting in basic JPEG mode, the same card could take around 2,000 images—a big difference!

Another point worth considering when choosing CF cards is their varying write speeds. The write speed is the speed at which the card receives and stores the information being fed to it by your camera. The faster the write speed, the quicker your camera's buffer will clear, and, in theory, the more shots you can fire off during any one opportunity.

Finally, there will come a time when you will actually wipe a card before downloading the pictures from it—this has happened to the best of us, but unlike when you spoil film by opening the back of a film camera before rewinding, there are possible methods of retrieving images that appear lost. Some CF card manufacturers supply recovery software with their cards, and these

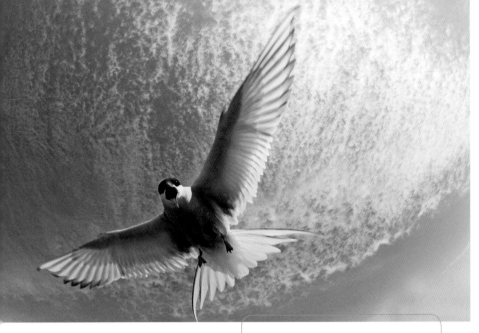

⬆ *When photographing action sequences such as with this arctic tern mobbing me on the Farne Islands, CompactFlash cards with high write speeds ensure that your images are accepted onto the card from your camera's buffer quickly, thus avoiding the camera locking due to the camera's buffer becoming full.*

10.5mm lens; ISO 200; 1/1000 sec at f/11

stems work well. There are also a number of ternatives to be found on the Internet.

Most DSLRs offer three different types of rmat to choose from for shooting in. They are EG, TIFF, and RAW. JPEG stands for the Joint hotographic Experts Group, which designed the rmat, and is a compression method used to ore images at a much smaller size. The JPEG is nown as a "lossy" format because the data is jueezed into a small space so that some is lost doing so. With a JPEG image, not all the color formation your camera is capable of capturing ill be kept, although this loss may arguably not e readily apparent to the human eye.

Every time you make adjustments to a EG and resave it, you lose information; this ccumulates so that over time deterioration in e image will be evident. JPEGs can be taken at variety of quality settings, from basic to fine. hen shooting in the JPEG format, you set certain arameters in your camera, such as the level of harpening, white balance, saturation, and so on, id these parameters are applied to the image.

RAW images are, as the name suggests, hages with no parameters set. Although e parameters you set in your camera will e attached to the picture file, they do not

have to be applied and can be modified in RAW processing software, downloaded to the computer. The other fundamental difference between JPEG and RAW is that a RAW file is not compressed.

PRO TIP

TIFF stands for Tagged Image File Format and is the one you are least likely to use. It is the common format used to convert a RAW file into. TIFF files take far longer than the other formats to be processed by your camera, and they take up a lot of space on CF cards, so there is no real reason to use the format, other than later in the work flow, when your pictures are downloaded to the computer.

RAW FILES CAN BE WORKED ON AND MANIPULATED IN THE COMPUTER WITHOUT LOSS OF IMAGE QUALITY. JPEGS ARE THE STANDARD FILE FORMAT FOR COMPACT CAMERAS AND THUS FOR DIGISCOPING, AND, DEPENDING ON YOUR AIMS, THESE IMAGE FILES CAN PRODUCE ACCEPTABLE QUALITY.

Which format to shoot— RAW or JPEG?

Many authors have debated the pros and cons of shooting JPEGs as opposed to RAW images. My advice is that if you have the ability on your camera to shoot RAW images, and your aim is to produce the best-quality image you can, then there is no debate: you should shoot in the RAW format.

If you are a digiscoper using a compact camera, shooting JPEGs is no problem. All this means is that you do not have the post-processing control you have with a RAW image, so you need to make sure that the parameters you set on your camera—white balance, sharpening, and so on—are set to give you the picture you desire.

When shooting JPEGs, make sure you are using the best-quality setting, usually defined as "JPEG fine"; lower settings will definitely affect the quality of your picture. Some of the advantages of JPEGs include being able to store many more images on a CF card compared to the much larger RAW files, the little work needed to

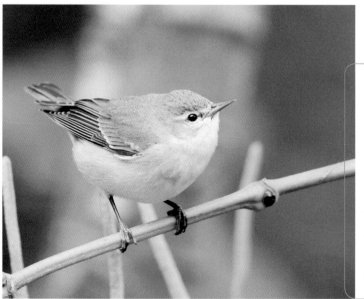

← I came across this Tennessee warbler late in the afternoon when the low sun was creating a warm glow. I did not want the warbler's plumage to be rendered too warm, but I did not have the opportunity to experiment with white balance in the camera. However, because I was shooting in RAW, I was able to adjust the white balance at the editing stage, re-creating the true colors of the warbler's plumage.

500mm; ISO 200; 1/50 sec at f/4

done to images once out of the camera, and
ally, all photo-editing software readily reads
G images, whereas RAW images may need
ecial plug-in software to read the files from
rtain camera models.

As mentioned above, if your camera gives
u the ability to shoot in RAW, the benefits are
on realized:

Color information can be lost from a JPEG file,
out a RAW file, if processed well and converted
to an RGB TIFF, will be superior. Having
said this, depending on your final use, this
superiority may not be immediately noticeable.
A RAW image gives complete freedom to
experiment with white balance, exposure, and
the various other parameters.
Every time you make an adjustment to a JPEG
and then resave it, you are slowly degrading
the image, although this will not be noticeable
if only done on a few occasions.
Processing RAW images for the first time may
seem like a daunting task, but it is not rocket
science and is soon easily mastered. Much of
what you do is down to judgment and common
sense (see page 110).

(see page 110)

PRO TIP

A digital camera RAW file is a copy of all the
data captured by the camera's sensor in a
single exposure, without the camera having
compressed or manipulated that data in any
way. This violet-bellied hummingbird was
photographed in RAW format (left), which
meant I could remove the blue cast without
loss of detail. The result is on the right.
200mm lens, ISO 200, f/5.6 at 1/250 sec
with full flash.

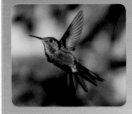 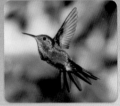

⊡ I poorly exposed this image of a female red-
necked phalarope, but because I had shot the
image in RAW, I was able to recover the subtle
colors without too much damage to image quality.

70–200mm zoom; ISO 100; 1/320 sec at f/5.6

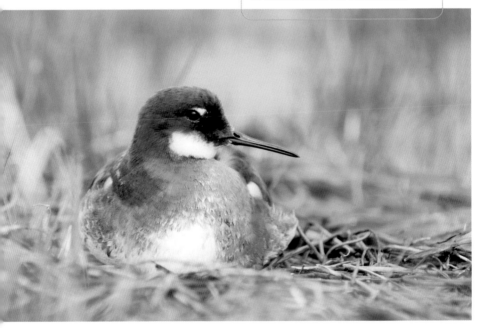

DUST IS THE GREATEST ENEMY OF DIGITAL CAMERAS, AND BY SHOOTING OUTDOORS
AND IN ALL SEASONS, YOU ARE ALSO LIKELY TO ENCOUNTER RAIN, SNOW, AND HAIL.
THERE ARE WAYS TO PROTECT AND CLEAN CAMERAS, BUT YOU HAVE TO WORK VERY
CAREFULLY AND THOROUGHLY.

Taking care of your equipment

**The very nature of bird photography means that equipment takes
a beating from the elements—whether it is getting covered in
salt spray, dust, or being rained or snowed on. Thankfully, there
are a variety of useful measures we can take to offer protection
and clean our gear.**

Dust is the big enemy: digital sensors are prone
to attracting dust particles due to the charge they
create, so changing lenses in dusty environments
should be avoided unless absolutely necessary.
To check how dusty your sensor is, take an image
of the sky with the lens stopped down to, say,
f/16 or f/22. The dust will show up, particularly
if you view the image at a hundred percent
on your computer screen. Some of these dust
particles are too small to matter. Larger particles
will appear on your pictures, and these will need
to be cloned out: this can be time-consuming,
so it is sensible to keep the sensor clean.

How you clean your sensor is really down
to personal preference. I hold my camera in the
air, with the front facing downward, open the
shutter by putting the shutter speed on the bulb
(B) setting, and then squirt air by hand using a
Giotto bulb blower. Holding the camera up so
that the front is facing down helps the dust fall
out. This works well for me and keeps my sensor
clean. Some experts discourage this technique,
however, suggesting dust might be pushed into
inaccessible nooks and crannies.

The alternative is to use a swab kit and/or
special brushes that use an electrostatic charge
to pick up the particles. A variety of these can
be found for sale on the Internet, but they can
be very expensive, ranging from a few dollars
to many hundreds. I would suggest never using
compressed air, as there is always the danger of
moisture being squirted onto the sensor, which
might then be very difficult to remove. If you
have stubborn marks, you can get your camera
manufacturer to clean the sensor. Nikon and
Canon offer this service for a fee.

← *Part of an image
enlarged 100 percent to
show a dust spot that
needs removing.*

I have a friend who persists on using [a]
shirt to clean his lens. This practice is not
[re]commended! When you take a close look at
[th]e end of his lens, it looks like people have
[be]en ice-skating on the glass! Whenever you
[cle]an a lens, use proper lens tissue or cloth.
[The]se can be bought cheaply at optometrists
[an]d are relatively inexpensive, compared to
[rep]lacing the lens front element.

Bad weather, such as snow or even heavy
[rai]n, can lead to some interesting opportunities
[wit]h birds and can transform a run-of-the-mill
[por]trait into an eye-catching one. When the
[we]ather does turn bad, you need to protect your
[ge]ar so you can continue shooting. You can use a
large plastic bag, but these do rustle and blow
around in the wind; it is far better to purchase
custom-made lens covers, which are available
from a number of sources, or you can make
your own—shower caps are a good idea for
protecting the camera in rain or snow.

⤓ *Photographing this parasitic jaeger was a
challenge due to gale-force winds blowing sand
over my gear and me. I covered my lens, and
I made sure all sand was removed from both
camera body and lens before taking them apart
and packing them away. Although there is a risk
of getting sand or dust inside your camera in such
conditions, you certainly should make the most
of adverse weather. This would have been an
ordinary portrait without the blowing sand.*

500mm lens; ISO 400; 1/500 sec at f/8

→ *Heavy snow makes for
very evocative images of
winter. I was well-sheltered
from the weather to get this
shot of a Scottish golden
eagle, and I had a lens bag
over my lens for protection.*

500mm lens; ISO 200;
1/250 sec at f/11

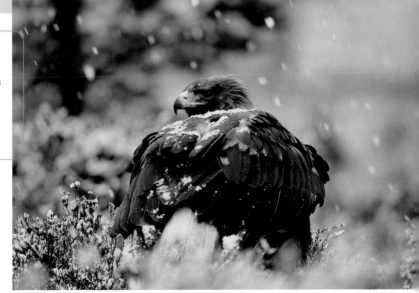

Photographing birds

ne of the questions I get asked most is, where can I go to get good
ictures? The easy answer is that there are opportunities all around
ou. You don't have to jet off to exotic locations or jump in your vehicle
nd travel to a bird reserve—if you have a backyard or a local park,
ese are great places to start, both to hone your skills using your
quipment and to practice your field craft.

hen my interest in bird photography started,
was a teenager with no transportation other
an a bicycle. So for years I would set off from
ome armed with my camera and attempt to
hotograph the birds local to me. I got to know
y patch very well, and I knew the opportunities
vailable at different times of the year. I often
iled, but on those days I managed a successful
alk and got what I considered a good picture,
made the pleasure all the sweeter, due to the
any disappointments I experienced.

Above all, this apprenticeship taught me
od field craft. I developed the ability to read
w close a bird would allow me to approach,
ecame expert in predicting behavior, and I
erfected my stalking technique. There is no
ubstitute for experience—good field craft is not
arned from a book such as this, although I can
ve you plenty of tips—you need to get out
and learn from your mistakes. Concentrating on
your local birds is the best way to start.

The next few pages give an overview on
how to tackle some birds common to a variety
of habitats, and this is followed by suggestions
for utilizing creative techniques.

When my pictures started being published
in the mid-1980s, good bird photographs were
those considered to be well-lit portraits, sharp
flight shots, and attractive images of birds at
the nest. Now, equipment has improved to the
point where the parameters of what makes a
great bird photograph are continually moving,
and there are new opportunities for capturing
pictures showing rarely seen behavior and
action. Although action pictures are currently the
new vogue, there is so much more to making a
good image than capturing a fleeting moment:
direction of light and perspective will always be
key elements to creating a strong picture.

*Bird photographers are often allowed privileged
glimpses into birds' lives. This group of snipe was
huddled together at dawn, having roosted in a tight
pack in the middle of a roadside pool.*

500mm lens; ISO 100; 1/500 sec at f/8

Backyard birds

There are few more productive locations in which to photograph birds than your own backyard. Regular feeding should soon lure a regular band of garden visitors, all lining up to have their pictures taken. If you don't have a backyard, it is worth approaching local landowners or even the folks at your local nature reserve to see if you can find a quiet corner in which to start a feeding station.

Some years ago I started feeding the birds at my local nature reserve, and before long I had hordes of birds queuing up to jump on the feeders. After using portable canvas blinds for a couple of years, I went upscale and had a converted wooden shed installed. You could utilize your garden shed,

⬇ *In Europe, wintering thrushes readily come to apples put out in the garden. This fieldfare was a regular visitor for a few cold weeks one January.*

500mm lens; ISO 100; 1/250 sec at f/11

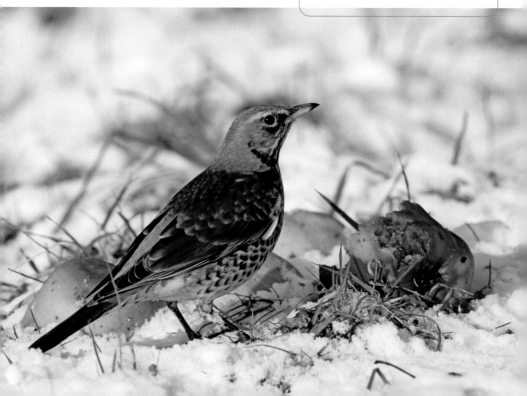

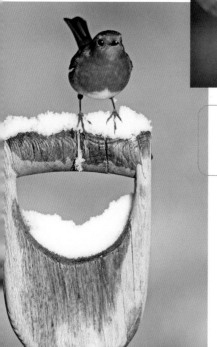

placed in a reasonable position for the light: [o]pen the window and place camouflage netting [a]cross, and you have a ready-made blind.

You might be able to shoot from your kitchen [w]indow; if your regular backyard birds are used [to] people in the house, you might not even need [to] be concealed. I don't need to use the blind for [so]me species at my feeding station, as some of [th]e blue tits are so tame they perch just inches [a]way when I am filling up the feeders. If your [b]ackyard birds are tame, this is a big bonus. But [re]member if you are not concealed, the shier [sp]ecies will stay away.

When setting up a feeding station in your backyard, go for a position where the sun will be behind you during the part of the day you intend to be photographing and match this with a good, clean background. If good backgrounds are hard to come by, you can easily manipulate this by placing a subtly colored cloth or board to act as an out-of-focus backdrop. I have two I use regularly; one painted in a pale blue wash to mimic the sky, the other in a nice soft shade of green. The great thing about backyard photography, as opposed to stalking birds in the wild, is that you can control the background lighting and perches.

In my experience, the key to attracting lots of birds is to put out as much food as you can afford and to provide as big a variety of food as possible. For example, I may have up to ten feeders, a bird table, and food sprinkled on the ground when not taking pictures. The advantage of attracting big numbers is that when you come to photograph you can remove nearly all your

feeders: this creates a queuing system, meaning birds have to perch around the feeders before there is space to jump on.

A variety of foods is key to attracting a good variety of species. In the United States, foods can range from sugar solutions for hummingbirds, fruit for tanagers and orioles (the latter like oranges sliced in two), mealworms for various species including bluebirds, and peanut butter smeared on logs and tree trunks for woodpeckers. Various seed mixes can be bought to attract specific species. Put niger seed out, and you are soon likely to have a regular flock of goldfinches; peanuts are great for tits and that common garden visitor, the great spotted woodpecker, while apples and pears are a big hit with thrushes.

The chances are that you will not want your pictures to feature the garden feeder that the birds are visiting, so the trick here is to place a

decent-looking perch close to the feeder but not too close so that it appears in the picture. The birds will then use the perch before jumping onto the feeder or bird table to feed. Perches can really enhance the picture—I often spend

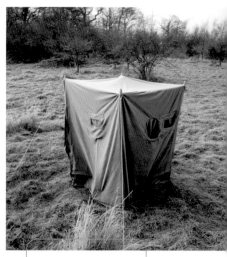

⬆ *Canvas blinds are very useful when photographing garden birds.*

⬇ *A white-crowned sparrow was lured into view by placing mixed seed below the bush.*
500mm lens; ISO 100; 1/640 sec at f/5.6

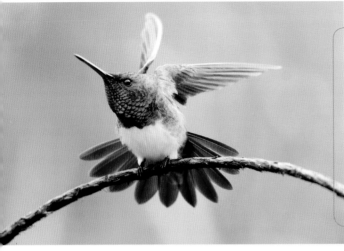

← *This beautiful snowy-bellied hummingbird was photographed in the gardens of a lodge in Panama. Because this hummer was coming back to rest on the same perch after each feeding foray, I was able to tidy up the background, eliminating a cluster of tiny branches that would have distracted from the bird.*

500mm lens; ISO 200; 1/125 sec at f/5.6

→ *If you have an attractive tree or shrub in your garden, simply place food close by and photograph the birds as they arrive and leave. I placed bananas on a bird table below this bare branch to attract this golden-hooded tanager to perch.*

500mm lens; ISO 125; 1/500 sec at f/5.6

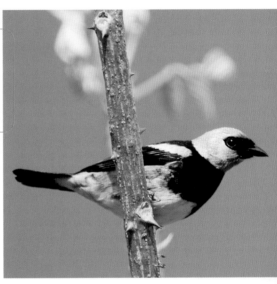

ng periods of time looking for suitable twigs, ranches, logs, and sometimes rocks to use. If ou snap a twig, make sure the break does not how, or if unavoidable, smear some mud over e break to disguise it. There are all sorts of icks you can use to get birds to use perches: or example, I regularly photograph robins on all orts of garden implements, luring them onto ork handles, flowerpots, and even a garden nome! I do this simply by placing mealworms an old film canister and taping it to the perch st out of shot.

Food is not the only way of attracting irds—they need water too, and a small pond simply a receptacle with a drip will work. perch can be placed out of sight of your eceptacle, or if birds are coming to a small ond, you can line the banks with moss or ther attractive natural features to hide any gns of the pond being man-made.

PRO TIP

If you have a decent-sized backyard, it is worth planting shrubs that produce berries and other plants attractive to birds. A well-placed rowan tree or other tree that bears berries or fruit will provide great photo opportunities for a variety of species during fall and winter. If you plant native shrubs or trees, your pictures will look all the more authentic.

Urban environments

Towns and cities may not readily spring to mind as great places to photograph birds, yet where birds come into close contact with people and are not harmed, they readily become tame. Town and city parks are the obvious places to visit within urban environments, offering green spaces where a range of species can feed, breed, and roost.

In central London, St. James's Park can be outstanding for bird photography, for example. One of the attractions here, as with many parks, is a lake that attracts a range of wildfowl; these waterbirds are fed daily by hordes of people, and so are easily approached. When visiting parks, I like to take my own food and move away from other people so I can control the birds more easily. Often the earlier you visit in the day the better, not just because of the light, but because once lots of people start appearing, the slightly more timid birds will become harder to approach, and lots of people throwing food out can make your quest to manipulate your subject's position very difficult.

Apart from the obvious waterfowl attractions of park lakes, any areas of woodland and shrubbery also yield results. Large areas of grass attract thrushes and other lawn-loving species to feed, particularly if lawn sprinklers are on.

Away from these green oases, many other opportunities exist, particularly for making

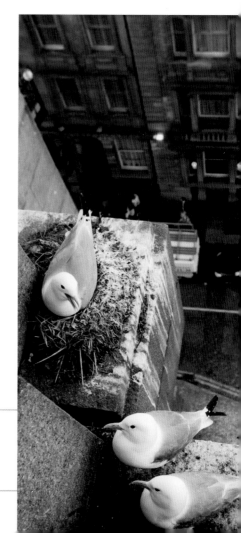

Towns and cities can be surprisingly good places for bird photography. These black-legged kittiwakes are nesting on building ledges in the center of Newcastle in northeast England.

17–35mm zoom; ISO 200; 1/160 sec at f/5.6

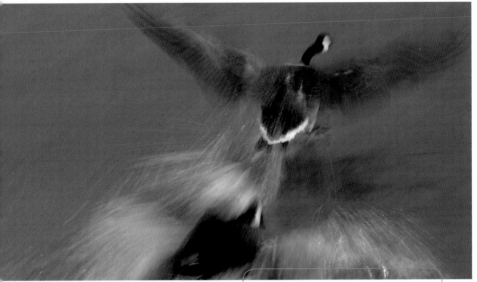

⬆ *This motion-blur image of squabbling Canada geese was taken in St. James's Park in central London.*
300mm lens; ISO 100; 1/15 sec at f/16

...ages that portray birds living in the urban ...vironment: I lived in the city of Newcastle ... northeast England for eighteen months and ...und a number of opportunities for doing ...st this. One of the big natural attractions in ...ewcastle is the kittiwakes that nest on the ...ildings close to the river, in the heart of the ...ty. They are so used to people coming and ...ing when roosting on their chosen nest ledges ...at I was able to get close enough to use a ...ide-angle lens, portraying the birds within the ...ntext of their urban environment.

Botanical gardens can be productive sites, ...rticularly as they are often in urbanized ...eas that offer a refuge for many species. Kew ...ardens in London is one such place where ... host of woodland species can easily be ...proached: pheasants strut through carpets of ...uebells in spring, while the wooded areas are ...vored by species such as wood pigeons that ...e difficult to approach in the countryside.

➡ *Familiar birds, such as feral pigeons, are likely to be very tame and thus offer good opportunities for close-ups.*
200mm lens; ISO 200; 1/500 sec at f/5.6

WHETHER SEEN IN FLIGHT BEHIND A BOAT, DIVING AFTER PREY, NESTLING IN COLONIES, OR FEEDING THEIR YOUNG, SEABIRDS ARE ALWAYS FASCINATING SUBJECTS, AND IF YOU CAN INCORPORATE THEIR ENVIRONMENT INTO AN IMAGE, SO MUCH THE BETTER.

Section 2

60

Photographing birds

Seabirds

Seabird colonies offer endless opportunities for bird photography. In the northern hemisphere, most colonies are alive with frenetic action from mid-May. North America has some special sites, not least the often fog-shrouded Pribilof Islands. Britain and Ireland play host to some of the most spectacular colonies in the world, too; the combination of sea cliffs bordered by the rich North Sea and North Atlantic means millions of seabirds make their home there.

The sheer number of birds at close proximity, the sounds—and sometimes the smell, too—is what makes a visit to a seabird colony so unforgettable. A full range of lenses will come in handy here: wide-angles can be used to shoot colonies on dramatic sea cliffs, for example, and there can often be very tame birds that can be used as foregrounds to a wider scenic shot. This

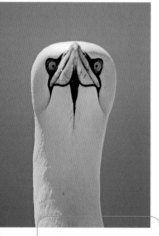

⬆ Seabirds are normally very approachable when breeding on land, allowing a creative approach. I knelt in front of this gannet and used a long lens to isolate its head and neck so I could capture its remarkable stare.

500mm lens; ISO 100; 1/500 sec at f/4

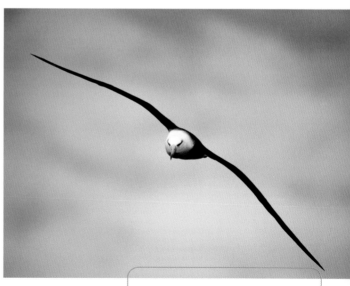

⬆ Many species of seabird follow boats, and a trip to Antarctica by boat is a great way of photographing albatrosses. This black-browed albatross was photographed from the stern of a ship, handholding my lens.

500mm lens; ISO 100; 1/1000 sec at f/5.6

a popular image with British photographers when photographing Atlantic puffins, which can be hand-tame—indeed, I have had puffins playfully tugging at my laces while sitting on cliff top!

Apart from images of static birds, flight shots should come thick and fast in many colonies, as birds come and go from their fishing grounds. Wind direction can play an important part in how successful you are with this, since the wind will determine in what direction to the light the birds arrive and depart from the colony. This is because seabirds, as with any other bird species, will, whenever possible, take off and land into the wind.

With the majority of species, photography is often best toward the latter half of the breeding season when birds are returning with food for their young. For those that do not nest down in holes or in crevices, there will be the rearing of chicks to photograph, offering interesting images of the interaction between parents and young.

Two things to bear in mind when photographing seabirds at a colony; first, avoid any undue disturbance—this is particularly true around tern and gull colonies, which should be avoided unless they can be photographed from a vehicle or custom-built blind. Secondly, take great care on cliffs: it is very easy to get wrapped up in taking pictures and lose all caution—accidents do happen!

Seabirds away from colonies are a different proposition altogether. Down in the Southern Ocean, if you join a cruise to Antarctica, great opportunities can be had from the ship photographing the albatrosses, petrels, and other birds that follow the boat. Closer to home, car ferries can sometimes offer opportunities for following gulls.

Seabirds on the wing offer a big challenge, particularly in a rocking boat. At many locations, pelagic trips are offered to view and photograph seabirds; perhaps the most outstanding can be found in New Zealand off Kaikoura, and California's Monterey is another favorite place for pelagic birds. The ideal lens for these on a small boat is normally a 300 or 400mm lens, perhaps coupled with a converter. The lighter and shorter the lens, the easier it is to follow birds while on a rocking boat.

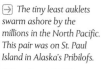

→ *The tiny least auklets swarm ashore by the millions in the North Pacific. This pair was on St. Paul Island in Alaska's Pribilofs.*

500mm lens; ISO 400; 1/160 sec at f/8; fill-in flash set to -3

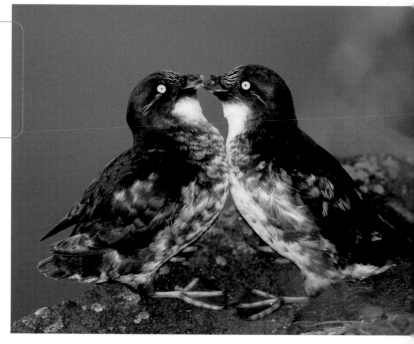

WILDFOWL AND WATERBIRDS TEND TO BE ON THE LARGE SIDE AND OFTEN CONGREGATE IN HUGE COLONIES, BOTH OF WHICH FEATURES MAKE FOR GOOD PHOTOGRAPHIC SUBJECTS. IN CONTRAST TO EVER-MOVING SEAS AND OCEANS, STILL LAKES AND MARSHES PROVIDE ATTRACTIVE REFLECTIONS.

Section 2

62

Photographing birds

Wildfowl and other waterbirds

Unlike small birds that require a close approach for a pleasing image, wildfowl, and families such as storks and herons, offer a variety of approaches, since these are big birds that reside in usually very open and sometimes very scenic habitats. As with seabird photography, a range of lenses can be employed to photograph them.

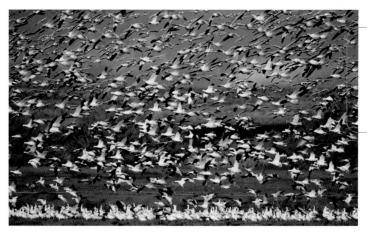

← The snow geese and Ross's geese in New Mexico's Bosque Del Apache Reserve offer the bird photographer a photographic feast.

500mm lens; ISO 100; 1/500 sec at f/8

Big flocks are a feature of wintering wildfowl and allow plenty of artistic interpretation. Goose flocks sometimes explode into the air, and post- or preroost flocks can be silhouetted against an orange sky.

How easy it is to stalk waterfowl depends very much on the location and can vary dramatically at different locations in the same region. This is due to many species being hunted, and where this happens, approaching them may be impossible. At refuges, however, where they are left alone, some species become very tame.

Many species give signs of imminent action—for example, whooper swans communicate by bobbing their heads before they take off, while many species of duck will shake their heads or also bob. As you gain experience, you will learn these various signs, which give you a warning to be ready with your finger on the button. Birds will always take off into the wind if they need a running start to become airborne, so by placing yourself on the flight path for takeoff, you can maximize your chances of getting a good action sequence.

Divers, grebes, and diving ducks can all be stalked by using a simple method of moving closer only once the bird has dived; each time it emerges, freeze, and don't move until it dives again. Another way of getting close to waterfowl on the water is to utilize a floating blind; these are becoming increasingly popular, and if you are reasonably good at DIY they are easily constructed. I used one for a few years, which enabled me to capture some really eye-catching, low-level images of ducks and swans, as they took little notice of the blind.

Herons, egrets, and spoonbills nest in colonies, and close approach can be made without risk of disturbance at some locations. Famous rookeries for photography include Bharatpur in northern India, one of the world's great wetlands where thousands of breeding waterbirds put on a spectacular show. At the other extreme is the Venice rookery in Florida, which consists of a small island in a small lake that hosts breeding great blue herons and great egrets. Despite this smaller scale, the photography here is no less spectacular.

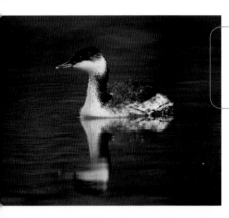

← *This horned grebe, photographed at a local reservoir one winter, was tricky to approach, but by moving only when the bird was diving underwater, I was able to creep close enough for a shot.*

500mm lens; ISO 400; 1/250 sec at f/5.6

↓ *This image of a pair of mute swans was taken at my local park just a minute or two after sunrise. Within ten minutes, the mist had burned off and this beautiful scene was gone. It pays to get up early, particularly with waterbirds.*

300mm lens; ISO 100; 1/500 sec at f/11

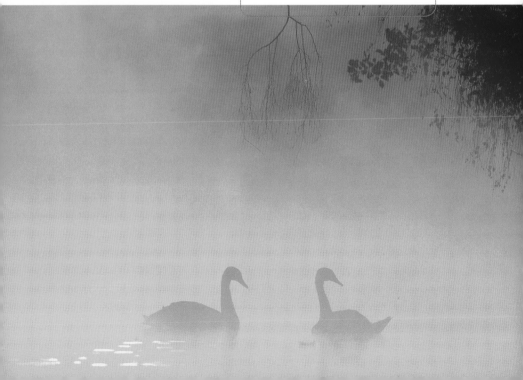

Birds of prey

**Attempting to photograph birds of prey in the wild offers a big
challenge. This is why many of the pictures you see published are
of captive raptors, often passed off as being in the wild (see page
72 for more on this). All species can be photographed given time,
patience, and knowledge.**

There are now a number of opportunities
available at baited sites. Baiting—that is the
putting out of food—is very effective in attracting
species ranging from golden eagles to red kites
and even ospreys. This is a far more attractive
proposition than attempting to photograph at
the nest, where many species may easily be
disturbed. Indeed, it is a criminal offense to
photograph a number of species at the nest
without the relevant licenses.

Because of the birds' shy nature, if you
are baiting a site you will need to use a blind.
Raptors have incredibly good eyes and may
sit out of sight of your blind for many hours,
watching the bait and looking for anything
suspicious before coming down to feed. This is
especially true of golden eagles—I once watched
a golden eagle from my blind in Finland for
seven hours before it finally flew down. It is thus
imperative not to create any suspicion when in
the blind, this means leaving your lens alone—
have it trained on the bait, but don't start moving
it around for no reason—and if you have to move
do it very slowly. With golden eagles, if I have a
bird on bait I may take two minutes or more to
move the lens just a few inches. You might think
this is overkill, but once the birds sense danger
they will go, and they may never come back.

Because raptors can sit concealed while
watching a baiting site, it is often best to arrive

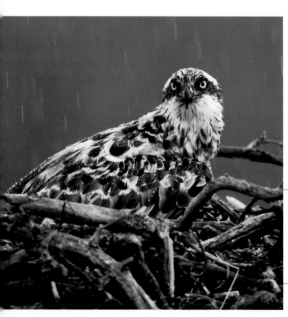

← *I have spent many enjoyable hours
photographing ospreys. This shot was taken from
a pylon blind (a blind on stilts) overlooking a nest
in Finland. The female was brooding her young
during torrential rain.*

500mm lens; ISO 100; 1/250 sec at f/4

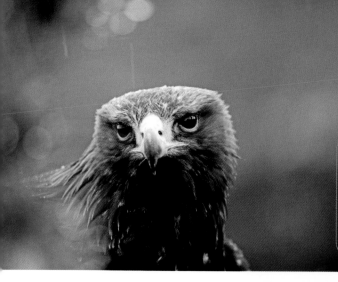

← *Golden eagles are very suspicious, so great care needs to be taken when photographing them and other raptor species from blinds at baited sites.*

500mm lens; ISO 400; 1/125 sec at f/5.6

→ *I was able to photograph this kestrel from above to give a more unusual perspective. A shallow depth of field concentrates the viewer's attention on the bird.*

300mm lens, ISO 200, 1/250 sec at f/5.6

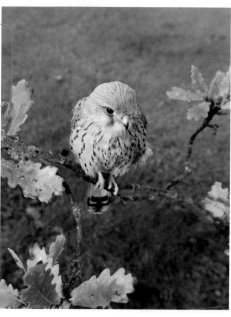

your blind in the dark if you are on your own, d leave in the dark, too. If you have a friend two who can walk to the blind with you and ave once you are inside, then it is probably OK do this in daylight, as the birds will be fooled o thinking any danger has left.

Not every species will need such measures, course. There are some opportunities that e commercially run for photographers, with erything, including the birds, arranged! These clude the sight of sea eagles in Norway, which e thrown fish from boats in the fjords—great tion images can be taken on these trips. In tain, Gigrin Farm in Wales is well known among d photographers as the place to photograph d kites. Here the farmer feeds the birds on nps of meat and fat thrown out in front of ow of blinds at exactly the same time each y. The birds know when to arrive, and over undred kites may be present performing an rial ballet in front of rows of telephoto lenses.

Perhaps the ultimate baited site I have visited n Finland, where close to Tampere, in the

south of the country, is a fish farm that attracts a constant stream of ospreys. Here the fish farmer has turned the marauding birds into a benefit by creating a special, sandy-bottomed pool that has been packed full of fish the farmer cannot sell at market. The birds line up to fish in the pool as it is so easy, and with the provision of photographic blinds the opportunities are spectacular. Opportunities for photography away from baited sites can be made at migration points, for example on Gibraltar, and in the United States at Cape May in New Jersey.

IN ADDITION TO TAKING PHOTOGRAPHS OF GAME BIRDS IN FIELDS AND IN FLIGHT,
THERE ARE REGULAR OPPORTUNITIES TO CAPTURE IMAGES OF LEKKING, WHERE LARGE
GROUPS OF MALE BIRDS DISPLAY THEMSELVES IN AN ATTEMPT TO ENTICE FEMALES.

Game birds, crakes, and rails

Game-bird photography is most popular in spring when some species
congregate at leks, the communal display grounds at which the males
display in an attempt to attract females to mate—in North America,
prairie chickens strut their stuff, while in Europe both capercaillie
and black grouse are the two big draws for bird photographers.

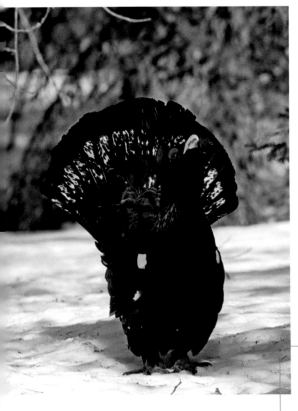

Lekking of most grouse species occurs early in
the morning and can often be over soon after
dawn, which presents the fundamental problem
of available light. I have experienced many
frustrating mornings in blinds photographing
capercaillie, witnessing fantastic behavior prior
to dawn, and then, once there was enough
available light to photograph, the lek fizzling out
and the males dispersing. Such experiences are
common, which means it is best to try and make
multiple visits. Due to the shy nature of most
grouse and the danger of disturbance at a lek, you
need to be in the blind while it is still dark. While
capercaillie leks are often deep in pine forests,
black grouse leks tend to be more in the open and
will normally go on longer into the morning, so
photography at these is less of a challenge.

In some years, "rogue" capercaillie are found
in both Scotland and Scandinavia; these are

← *This is a male rogue capercaillie photographed
in early spring in Finland. Rogue capercaillie offer
great photo opportunities due to their fearless
nature–but beware, they often attack!*

300mm lens; ISO 100; 1/250 sec at f/11

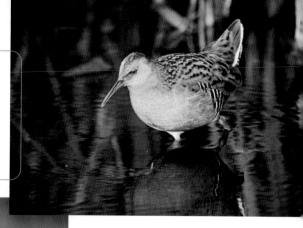

→ Water rails, in common with many species of crakes and rails, are normally very shy, but they can be enticed to a regular spot with bait. I used peanuts to entice this bird into the open.

500mm lens; ISO 400; 1/250 sec at f/5.6

← Male black grouse attend traditional leks in spring, where they display to attract visiting females with which to mate. This male was photographed from a blind set up to take low-angle shots.

500mm lens; ISO 100; 1/500 sec at f/4

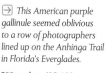

→ This American purple gallinule seemed oblivious to a row of photographers lined up on the Anhinga Trail in Florida's Everglades.

300mm lens; ISO 100; 1/500 sec at f/8

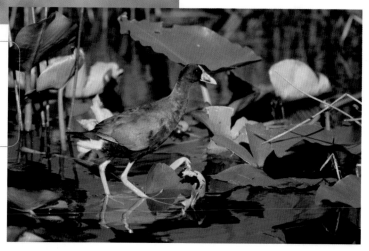

ales that are completely unafraid of humans nd will indeed attack. They are so pumped up at they display to anyone who approaches— ey make great photo subjects, but beware hen around them, as you can end up receiving nasty peck.

Away from the breeding season, game birds, rticularly pheasants and partridges, can be tracted to bait. Corn spread on the edge of lds or on woodland boundaries may entice red-legged and gray partridges, as well as the ubiquitous pheasant. Crakes and rails can be enticed into the open with bait, too. I have photographed sora rails coming to mealworms, and other water rails can be baited with casters (maggot chrysalis), peanuts, and a more natural food, hawthorn berries. During the breeding season, many species will respond to tape playback, although this of course needs to be used judiciously, and within the law.

MIGRANT SHOREBIRDS CAN TRAVEL THOUSANDS OF MILES EACH YEAR, SO THOSE YOU PHOTOGRAPH MAY HAVE COME FROM THE OTHER SIDE OF THE WORLD; ON THE SAME SHORELINE YOU CAN ALSO SEE "LOCAL" BIRDS, WHOSE WHOLE LIVES ARE SPENT THERE.

Section 2

68

Photographing birds

Shorebirds

Shorebirds are a big favorite for many bird photographers. Many species undertake remarkable migrations of many thousands of miles, while others are more sedentary in their habits. The approachability of many shorebirds is very dependent on location in the world, so very different techniques need to be employed, depending on how your birds react to people.

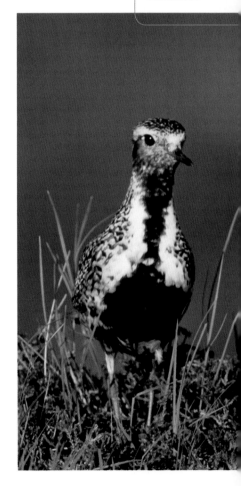

Some species of shore such as this Eurasian golde plover photographed in Sco are easier to photograph d the breeding season, when also look their best.

500mm lens; ISO 100; 1/250 sec at f/8

In North America, many shorebirds are very tame: Jamaica Bay in New York State, for example, is a popular spot for photographing migrant waders in the fall. Here a close approach can be made to most species, so stalking techniques can be used. One of the reasons for their approachability here in the fall is that many may not have seen a human before, having been born just a few weeks earlier. Contrast this with Europe, where many waders do not tolerate human approach: clearly stalking can be out of the question here. To take the knot as an example, in Florida and other sites in the United States, you can often approach this species on foot to within a few feet, while in Great Britain it is likely that a knot will take flight once you are within two or three hundred feet at best. Many bird reserves in Europe have good blinds suited to shorebird photography. The alternative to those on reserves is to use your own blind.

Each fall I erect a blind at my local reservoir on a pool where water levels are controlled just for the birds' benefit. The gradual growing expanse of mud as fall progresses attracts migrant waders such as common and green sandpipers, greenshank, snipe, and sometimes rarer visitors. I set my blind up for the early

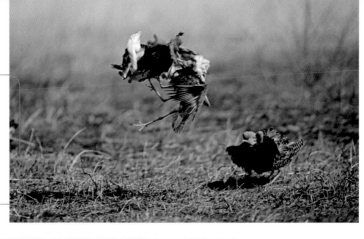

→ *A few shorebird species gather at lekking sites in spring to attract a mate. Some spectacular action can take place in these avian arenas, such as these male ruffs in combat.*

500mm lens; ISO 200; 1/1000 sec at f/4

← *During fall and winter it is worth visiting shorebird roosts. These red knots are gathered at the famous high tide roost at Snettisham on the Wash in southeast England. This shot was taken from the public blind.*

500mm lens; ISO 200; 1/250 sec at f/4

orning light, so the sun rises just to one side of before moving around the back; this gives me well-lit scene for a few hours. I have the blind t for early mornings so that I can arrive and ter it in the dark: this way I don't arrive, scare erything away, and have to wait a long time r all the birds to return.

Alternative sites for shorebird photography clude coastal sites where there are regular osts. If you know of a popular roost site, you n set up your blind and wait for the birds arrive at high tide. Some roost sites can be ectacular—more than 100,000 birds can be esent, creating a photographic feast as they heel around in vast, tightly packed flocks.

PRO TIP

Where shorebirds share beaches or harbors with people, they are often far more approachable than those feeding far out on mudflats. It is always worth investigating busier beaches for this reason. If you spot shorebirds feeding along the tide line, watch which way they are moving and sit down ahead of them. Chances are, if you are still, they will come close enough for a picture.

Passerines

As a general rule, the smaller the bird, the faster it moves, and the more difficult it can be to photograph. The warblers are a good example of a family that require plenty of field craft to obtain good images. Apart from the problems of getting close and having to use long lenses, the added challenge when photographing small passerine species is to create pleasing images within their often cluttered habitat of twigs, branches, and messy backgrounds.

Getting a good background is often just down to perseverance, but also be aware of what a difference moving an inch or two can make with a long lens. In addition, by using a shallow depth of field with a long lens, even the most cluttered of backgrounds can be transformed into a pleasing backdrop.

Stalking passerines can be a big challenge, and it is far better to try luring the birds to you. We have already discussed backyard feeding

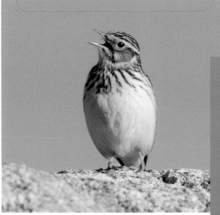

⬇ *Driving down a mountain road in Greece with the window open one morning, I heard a woodlark singing. I eventually located the bird on a boulder. By recording its song and then playing a quick burst back to the bird, the woodlark was soon singing on a boulder right by my car.*

500mm lens; ISO 160; 1/750 sec at f/8

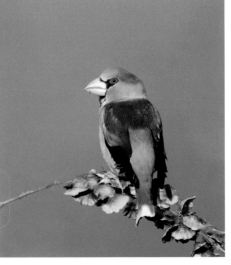

➡ *Most birds need to drink and bathe regularly. Hawfinches commonly come to drinking pools.*

500mm lens; ISO 160; 1/500 sec at f/5.6

⤓ Warblers present the photographer with a big challenge, as their fast and erratic movement, often through heavy cover, means perseverance is often needed. They are easier to photograph at migration watch-points in spring and fall. This paddyfield warbler was photographed on the Isles of Scilly in England one October, where there was little cover to hide away in.

500mm lens; ISO 100 with fill-in flash; 1/125 sec at f/8

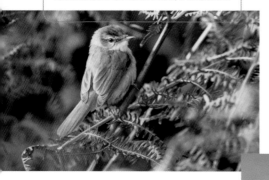

→ This robin visits my garden birdbath regularly to both drink and bathe. Water is a big lure for birds, particularly during cold snaps in winter when this shot was taken, since many water sources will freeze. I took this image to illustrate the robin in the garden; however, if you want more natural-looking shots, you can easily make a small drinking pool and landscape it with natural materials from the countryside.

300 mm lens, ISO 160, 1/250 sec at f/5.6

ations, but don't restrict your feeding just to the ckyard. Water is the other big magnet for birds ice most need to drink and bathe regularly keep their feathers in good shape. In hot cations, a drinking pool should not take long start working; a simple saucer or upturned rbage-can lid sunk into the earth and then ed with water will do, and by placing a perch ose by, you are immediately in business. In orth America, photographers have found that ater drips work really well for attracting a range species, particularly warblers—simply suspend water receptacle above a pool or dish and let slowly drip from a small hole in its base. The ecies and country you are photographing in will ctate whether a blind is necessary.

The other commonly used method for luring ngbirds in particular is to use tape playback in spring, either by playing a prerecorded song or recording the song of a singing male and playing it back. For some photographers this is unacceptable, but I have no qualms about using playback in a limited way. Where it should not be done is at sites where birdwatchers use the technique regularly to see certain birds, as the constant stream of visitors playing songs at a particular site can have a detrimental effect on a bird's well-being—if the bird does not respond within one or two plays, it should be left alone.

There are plenty of recordings available, and you can use an MP3 player or a small CD player with speakers to transport around in the field. I prefer to playback a bird's own song, as this normally evokes a stronger response. To be really accurate with where you want the bird to land, you can place a speaker next to the perch.

IF PHOTOGRAPHING A WILD BIRD, PARTICULARLY A BIRD OF PREY, IN ITS NATURAL HABITAT IS NOT AN OPTION, IT IS POSSIBLE TO FIND CAPTIVE BIRDS IN SPECIAL CENTERS. FALCONERS OWN RAPTORS, AND THEY WILL OFTEN WORK WITH PHOTOGRAPHERS TO CREATE NATURAL-LOOKING SHOTS.

Captive birds in natural surroundings

Working with captive birds can open up all sorts of creative possibilities difficult to repeat with wild individuals. All the keen photographers I know photograph captive birds—for many of us, the chance of photographing a wild golden eagle, for example, is one that is never going to happen (unless we invest an enormous amount of time and have the miraculous opportunity and access). The trick to photographing captive birds, whether they be ducks in a wildfowl collection or raptors owned by a falconer, is to make them look wild.

Much care and attention is needed to execute this type of bird photography properly. If you are photographing birds of prey with a falconer, then arrive at the location at least an hour early. Scout it out, look for suitable perches, and think about light direction, backgrounds, and opportunities for getting creative with different angles. If you take the time to know exactly where you want to place the birds and the type of shots you want from the session, you will have a much better chance of success.

If the raptor you are shooting has jesses on, try to conceal them by placing that leg behind the other, or perhaps place some foliage in front.

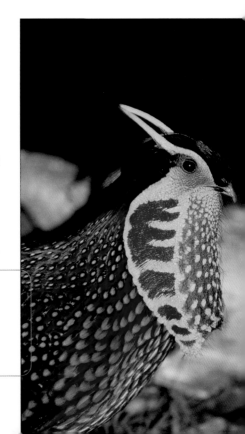

→ Just because they cannot escape does not mean that captive subjects are any easier to photograph. This Temminck's tragopan lived in a large enclosure. Only by sitting quietly in one corner for a couple of hours was I able to take this image of a male in full display.

500mm lens; ISO 200; 1/250 sec at f/5.6

sometimes use out-of-focus foregrounds to disguise the legs of a bird, either by shooting at a low angle along the ground or placing an object close to the lens in the line of focus. Of course, you can clone out unwanted telltale signs that the bird is captive; however, this can be very time-consuming and is often rather tricky.

The other popular captive subject for bird photographers in Great Britain is wildfowl. When shooting this subject, the one thing to remember is to conceal the pinioned wing by photographing the bird on its "best side."

Occasionally opportunities present themselves in zoos or other captive collections. When shooting through netting or bars, ensure you hold your lens flush up against the wire to prevent the picture from being soft or showing evidence of the bars. If there is a cage in the background, try to disguise this by using a shallow depth of field to help throw it out of focus.

It is good practice to declare that a photograph is of a captive bird; this is particularly important if you have your work published—and if you enter competitions, you will certainly have to.

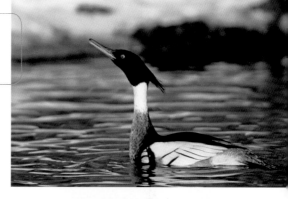

→ *Some great opportunities are offered by wildfowl collections. Here, a male red-breasted merganser is displaying in early spring.*

500mm lens; ISO 100; 1/500 sec at f/4

↓ *Captive birds allow you to get some great close-ups; owls' faces are a particular favorite of mine. This is a tawny owl I have worked with on a number of occasions.*

55mm lens, ISO 160; 1/250 sec at f/11

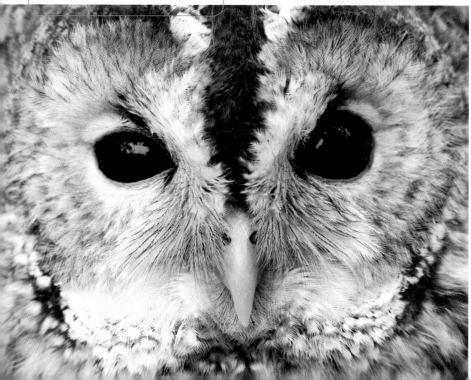

SHOOTING BIRDS IN FLIGHT IS ONE OF THE BIRD PHOTOGRAPHER'S BIGGEST CHALLENGES. GETTING THE BEST RESULTS REQUIRES A COMBINATION OF GOOD POSITIONING, FORWARD PLANNING, AND A THOROUGH KNOWLEDGE OF YOUR CAMERA'S AUTOFOCUS CONTROLS.

Birds in flight

The biggest hurdle to overcome when taking good flight shots is finding the opportunity to be in the right position. Regular flight paths that provide opportunities include bodies of water where wildfowl will be taking off, such as on the edge of a tern colony or perhaps on a migration route. By carefully identifying such locations, good opportunities will come your way.

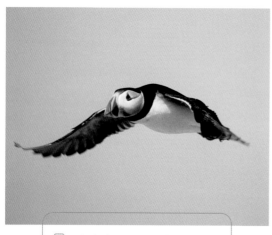

⬆ *Seabird colonies are good places for flight shots. I blurred this Atlantic puffin's wings for a more artistic effect.*

500mm lens handheld; ISO 100; 1/1000 sec at f/8

Whenever I am out with my camera, I am on the lookout for unexpected flight shots. Some of my best images have come from spotting a bird heading toward me and then being ready to take advantage of the situation very quickly. Using quick-release plates on lenses will help yo speed up when whipping your lens off a tripod.

Autofocus will have no problem locking onto birds against clear backgrounds, such as blue sky or water, but problems can arise when you track a bird against a landscape—if your autofocus point wanders off the bird, it may easily lock onto the background, so that suddenly you are struggling to lock the focus back on again. When this happens, take your finger off the shutter button and depress again once the bird is in the viewfinder—by keeping the shutter

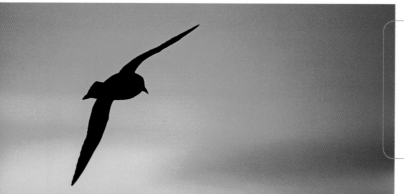

⬅ *Just as with composing a static bird, try and place a flying bird in the frame for a pleasing composition. I was able to place this silhouetted cape petrel close to the top of the picture, so it was flying into space.*

500mm lens; ISO 50; 1/500 sec at f/5.6

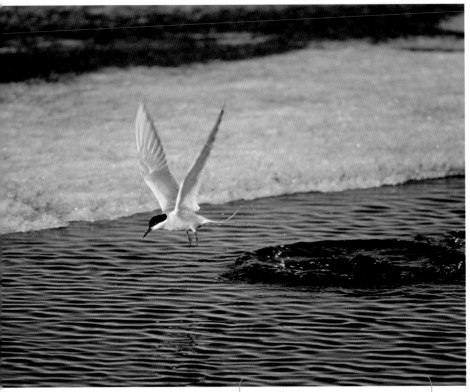

⤒ *Flight shots do not always have to be frame-fillers: I wanted to include the ice and the splash from this common tern's successful fishing attempt, so I used a shorter lens.*

300mm lens; ISO 200; 1/1750 sec at f/8

utton depressed, the autofocus might start unting and the opportunity will be lost.

I normally use the middle autofocus sensor r tracking flying birds, and on a big bird I try to cus on the neck or head so that the eye will be arp. By focusing on the body when firing the utter, it is possible to lock onto the wing on the ownstroke; if you are using a shallow depth of eld, the head of the bird will be out of focus—of urse, this is easier said than done!

Because of their low contrast, white birds can ause autofocus systems to hunt. There is no easy nswer to this, other than using a combination of utofocus and manual focusing if your lens allows. ometimes I resort to focusing manually on a reset point and shooting a burst of images as I ee the bird coming into focus in the viewfinder. nis normally captures at least one sharp image.

Flight photography is best attempted with ghtweight 300mm and 400mm lenses; however,

I do hand-hold my 500mm lens regularly. The key requirement is to use a fast enough shutter speed, at least 1/500 sec.

PRO TIP
- - - - - - - - - - - - - - - - - -
When photographing birds in flight, have your motor drive set to the fastest speed and take as many pictures as possible. Try to pan at the same speed as the bird. Using a Wimberley or Dietmar Nil tripod head will help with smooth panning and purposefully slow shutter speeds.

THE BEST BIRD PHOTOGRAPHY NARROWS THE GAP BETWEEN THE HUMAN AND AVIAN WORL

REVEALING BIRD LIFE AS OTHER BIRDS MIGHT SEE IT. ANGLING SHOTS OF BIRDS AT THEIR

LEVEL GOES A GOOD WAY TOWARD THIS, AND THE RESULTS ARE OFTEN WORTHWHILE.

Section 2

76

Photographing birds

Shooting low

If you compare an image taken at a bird's-eye level with one taken looking down from a fully extended tripod, there is no contest as to which will look best. Eye-level images create an intimacy between bird and viewer, thus having greater impact, while an image looking down on a bird usually gives a sense of detachment.

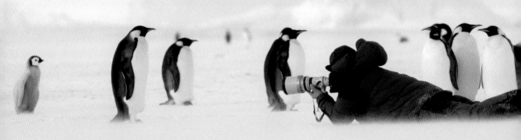

⬆ *Photographing an emperor penguin chick at its level.*

Now I am not suggesting that shooting low-level images is the only and best way to photograph birds—however, a low level does create more pleasing images than a higher viewpoint: out-of-focus foregrounds and backgrounds then become soft washes of color, which help to throw emphasis onto the bird.

Your neck will be badly cricked if you attempt to look through the viewfinder when laying on

the ground. The best solution is to use a waist-level or angled viewfinder that attaches to the eyepiece of your camera. I normally mount my camera on my tripod with its legs fully splayed or alternatively rest the lens on a beanbag. On occasion, I just rest the lens on the ground using

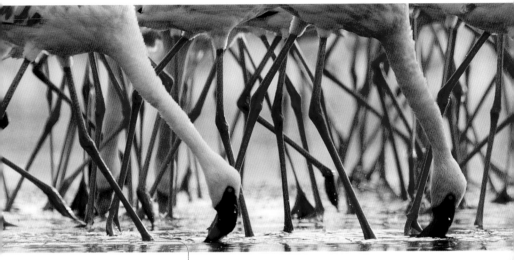

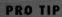 *This image shows lesser flamingos feeding and is a maze of legs. Taken at Lake Nakuru in Kenya's Rift Valley.*

500mm lens; ISO 200; 1/400 sec at f/11

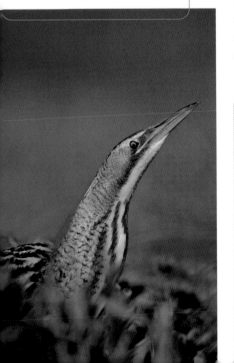

↓ *I was able to approach this bittern in a shallow-bottomed boat. By laying down, I managed this intimate view as it peered at me from between the reeds.*

500mm lens; ISO 100; 1/350 sec at f/4

the lens mounting foot, though this setup is not particularly stable. If you don't want to lie on the ground, by using a long lens and standing back, the angle of view will be shallower. Start to move in closer to a bird while standing with a long lens, and you will notice that the viewing angle becomes more acute.

Wildfowl are a good subject for shooting really low. If you can find a park lake that has a path low to the water surface, then by laying down and shooting the birds on the water, it can appear as if you are in the water with them.

PRO TIP

It is easy to lose a sense of the horizon when shooting low and thus end up with a great shot except for an obvious tilt in the background. Always check the horizon position behind your subject, and if you find the terrain a problem in this way, try using a small spirit level. These are available from some camera stores and can be stuck in an appropriate place on your camera.

Lighting

The quality and direction of light falling on a bird has a big effect on the mood created in the image. The best light of the day generally occurs in the couple of hours after the sun rises or before the sun sets, as the golden glow of the sun low in the sky really enriches colors. However, on bright, overcast, or cloudy days, I have no qualms about taking pictures throughout the day. Even on bright, sunny days, if a good opportunity for an image arises, I take it.

⊼ *This great bustard, strutting across the Extremaduran Steppe in Spain, is beautifully front-lit, helping to bring out the rich colors in this male's plumage.*

500mm lens; ISO 100; 1/500 sec at f/8

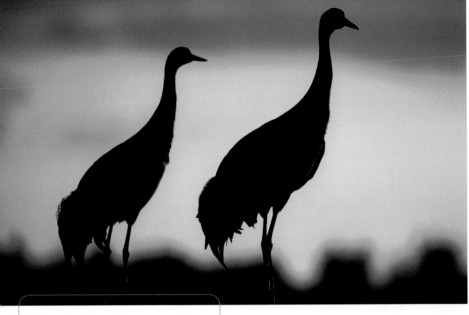

↑ One of my favorite silhouette images, this pair of common cranes are about to depart for an overnight roost on Lake Hornborga in Sweden. They walked to the top of the rise above my blind before taking to the air.

500mm lens; ISO 100; 1/250 sec at f/4

though midday light can be harsh, this is not a
ason to pack the camera away. Fill-in flash can
elp soften harsh shadows, and Photoshop can
e used to easily create catchlights in eyes when
ost-processing. Having said all this, as soon as
y shadow becomes shorter than me when the
n is shining, I do ease off a little until the light
proves later in the day.

There is always a temptation to shoot nicely
ont-lit bird images: colors are rendered well,
ere are few shadows created, and many
easing images are created in this way. For shots
e this, you need to ensure the sun is shining
om over your shoulder. However, I would urge
ou to experiment with the direction of light,
nce more eye-catching images can be made by
ucking the trend. While front-lit images are two-
imensional in appearance, you can create more
erceived depth in an image when there
a three-dimensional look. To achieve this,
ou have to use the light's direction to create
ontrast with shadow.

PRO TIP

When photographing birds with iridescent feathers, you want to be able to bring out these colors. Watch a hummingbird, and you will see flashes of color, depending on how the light hits the bird's plumage. Normally, to capture these colors on film, you need to be straight on to the bird as it faces you. Using a flash can help.

This stunning picture of a male rufous-crested Coquette hummingbird was photographed in Panama, and for the most part showed a black throat and breast. Only when it turned toward me did I see this beautiful emerald green display. I used fill flash to help in showing this off.

The other lighting options are sidelighting and backlighting. Sidelit images can look dramatic, elevating a pleasing portrait to something more striking. Sidelighting works best when the sun is low—this kind of shot is not so effective in the middle of the day—and I also find that shooting low helps. You should ensure that the lit side of the bird is correctly exposed, because if any areas are burned out the effect is lost; by exposing for the lit side, the shadows will take care of themselves. Sidelighting can give a three-dimensional look to an image that is particularly effective with large birds.

Backlighting can be dramatic, too; the mood of a picture shot from the front can be completely altered by shooting in the opposite direction, but watch out for lens flare caused by internal reflections from lens elements. Chipped or scratched glass or dirt on the lens can also cause problems; to avoid this use a deep lens hood, or try shading the top of the lens with your hand. When using backlight you can achieve a wonderful rim-lighting effect if your subject is against a dark background—the outline of the bird becomes lit up, as if wearing a halo.

Silhouettes can be produced through strong backlighting, aligning your bird in line with the setting or rising sun, or at least against a bright, colorful sky. Bird silhouettes work best when the outline is easily recognizable. Examples might be a cormorant drying its wings, a crane silhouetted in flight, or perhaps an eagle.

Good silhouette shots are rarely unexpected; they take a bit of planning and knowledge of favored perches or flight opportunities. It is then a matter of waiting for the right conditions and hoping the bird cooperates by using the chosen perch.

To what degree you silhouette your subject is personal choice, often any exposure to within two or three stops will work, the variance being the intensity of the colors in the sky. You can control this in Photoshop and, if shooting in RAW, in the camera's RAW converter. I tend to expose for an area of sky that is close to the sun but does not contain the brightest part and then use this as a base reading. You can experiment, but remember that when your histogram has the silhouetted bird in the frame, it will show tall spikes on the left-hand end, indicating clogged or almost clogged blacks. Don't worry about this since you are aiming to achieve the shape of the bird rather than showing any plumage detail.

← *The sidelighting on this northern goshawk helps accentuate the feeling of a ruthless predator and adds a mood that might have gone missing if conventionally lit.*

500mm lens; ISO 100; 1/250 sec at f/5.6

To achieve effective silhouettes, you ideally
[ne]ed to be in fairly open habitats—the flatter
[th]e better—as the best results will be shot close
[to] sunrise or sunset. Stretches of water, deserts,
[es]tuaries, and marshes all make great locations,
[an]d waterbirds are a favorite subject for these
[typ]e of images. Flocks of birds can be effective—
[th]ere are really plenty of options.

↑ *Cranes are very photogenic; this roosting
flock of sandhill cranes was photographed at
dawn through the "red mist" that can occur as
the sun rises in front of steam coming off water
warmer than the air temperature. This image was
shot at Bosque Del Apache National Wildlife
Reserve in New Mexico and won me a category
at the International Wildbird Photographer of the
Year competition in 2003.*

500mm lens; ISO 100; 1/250 sec at f/16

← *Snow is a great reflector,
and reflected light can help
make some sweet-looking
images. Look how the pine
needles and Siberian jay
are beautifully backlit, as
well as being enhanced by
the reflected light from the
snow below. This image was
taken in Kuusamo in Finland
in April.*

300mm lens; ISO 100;
1/250 sec at f/8

ACTION SHOTS OF BIRDS COME FROM KNOWING YOUR SUBJECT'S BEHAVIOR SO THAT YOU CAN ANTICIPATE THE MOMENTS OF DRAMA. CERTAIN TIMES OF DAY, PARTICULAR SEASONS, AND WEATHER CONDITIONS CAN ALL AFFECT BEHAVIOR, SO THAT KNOWLEDGE OF THIS, COUPLED WITH ATTENTION PAID TO PARTICULAR BIRDS OVER TIME, WILL ALL HELP.

Section 2

82

Photographing birds

Capturing action

Successful action photography has a lot to do with anticipation, and having a knowledge of bird behavior will give you this edge. The more you shoot pictures of birds, the better you will get at recognizing the signs a bird gives off before taking off—wing stretching, for example.

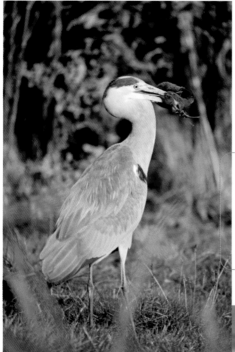

If the bird you are photographing is new to you it might be that watching it for a while will reveal telltale signs of imminent behavior. A goo example of this is exhibited by the great skua: when great skuas are on their breeding grounds they are highly territorial. When on duty at the nest, if another skua flies over, they stand, raise

⬅ *A gray heron has just snatched a water vole. This image is not particularly aesthetic, but it does illustrate a rarely witnessed piece of behavior.*

500mm lens; ISO 200; 1/1000 sec at f/5.6

➡ *Most large birds need to take off into the wind. I caught this shot by placing myself upwind of this mute swan that showed signs of wanting to take off.*

500mm lens; ISO 320; 1/500 sec at f/8

⬆ *While photographing these white storks on their rooftop nest in central Spain, I noticed that each time one of the pair got ready to depart, they would go through a bowing ritual, and the bird departing would ruffle its feathers. This gave me the signal to be ready to capture this image.*

135mm lens; ISO 100; 1/1000 sec at f/8

eir wings, and call with outstretched necks. So, y sitting close to a skua's nest and watching for approaching bird, you can ready yourself and otograph the warning display as it happens.

When fast and furious action occurs, keep ur finger on the trigger. Often a fight, takeoff, some other frenetic activity can happen so st that the eye cannot assimilate what is going , and it is only when you look at your pictures terward that you realize the exact sequence events. If the action is slow, such as a lazy ing stretch, you may have time to choose your oment and check that the bird is well-framed d that you have sufficient depth of field to nder both the bird's body and wings sharply.

One of the temptations when photographing ds is to try and get too close. With action— rticularly if this involves more than one bird— ck off so there is plenty of space around the bject and the picture can breathe. The other ason for backing off is to ensure that you don't t off wing tips or have depth-of-field problems, here critical parts of a bird are out of focus. If otographing aggression or even a fight, make

sure you have a fast enough shutter speed to freeze the action; most fights will need a 1/1000 sec speed to freeze movement, unless of course you want to blur the picture intentionally.

When photographing interesting behavior, it is always a trade-off between a fast enough shutter speed to cope with the movement and a small enough aperture to ensure enough depth of field. If a bird is raising its wings, yawning, or doing some other activity that is not particularly fast, if you take enough shots you might get away with a relatively slow shutter speed, thus allowing a decent depth of field.

Action photography inevitably leads to a big culling of images during the editing process. Take as many images as you can to increase your chances of capturing that one special image— believe me, when you do, it is a fantastic thrill!

FOR MANY BIRD PHOTOGRAPHERS, STALKING A BIRD TO GET A PICTURE IS A GREAT
PLEASURE; PERHAPS IT IS THE PRIMEVAL HUNTING INSTINCT COMING TO THE FORE, WITHOUT
THE DESIRE, OR THE NEED, TO ACTUALLY CAPTURE THE BIRD—EXCEPT AS A DIGITAL IMAGE!

Stalking and field craft

**Stalking is simply moving in close to a bird on foot—often by exercising
stealth and the use of techniques to help communicate to the bird
that you are not a threat. Successful stalking is less about pitting your
wits against a bird and more about having a bird accept you into its
environment, and it is immensely rewarding in itself.**

Once you have spotted a bird you wish to move
in close to and before you even take the first step,
ensure that your camera is on, your exposure is
sorted, and you are ready to take pictures. Decide,
too, whether you will be kneeling or standing
up, so that your tripod legs are at an appropriate
height—you don't want to be in the optimum
position and find you have to adjust your gear,
as this may flush the bird.

Once you are ready, start your approach,
holding your tripod in front of you. Each time the
bird stops feeding and looks or cranes its neck,

⬇ *This Wilson's phalarope vagrant turned up
one fall in the southwest of England. At first I
found it hard to stalk, but by sitting close to its
favored feeding spot, I was gradually accepted
by the bird.*

500mm lens; ISO 200; 1/350 sec at f/5.6

↑ *A common pauraque sits motionless on the forest floor. Birds with such cryptic camouflage will often sit tight, allowing intruders to come quite close. With this individual I had to find a window through the foliage to ensure its head was in clear view; this meant a very slow and cautious approach, trying not to make too much noise on the crunchy leaf litter underfoot.*

500mm lens; ISO 400; f/4 at 1/80 sec

...reeze; then, once the bird is relaxed again, take ...few more steps, making sure there are no ...udden movements. It is a good idea not to walk ...irectly toward your bird, but to take an angle, ...s the bird is likely to feel less threatened by ...his method. As you move closer, stop and take ...ictures; the bird will become used to the sound ...f the shutter and your presence.

With practice you will be able to detect when ...bird is not comfortable and is likely to fly and, ...milarly, when your subject is relaxed, you will ...ecognize the body language that reflects this. ...ever harass a bird that keeps flying ahead of ...ou, because eventually it will fly away completely.

Stalking your subject often becomes a special ...pportunity that allows you a privileged insight ...to a bird's life. My first such encounter was ...ith a snow bunting on the Isles of Scilly in ...ngland one October, which was feeding on grass ...eeds on some flat turf on a cliff top. At first I ...ied to approach, but the bird just kept flying a ...hort distance, never allowing me to get close ...nough. I then decided to sit still on the edge of ...s favorite feeding area, and the bunting edged ...oser and closer, until at times it was actually ...o close to focus on. Clearly it perceived me as ...nthreatening once I was sitting quietly, and ...nce I was accepted, it ignored me.

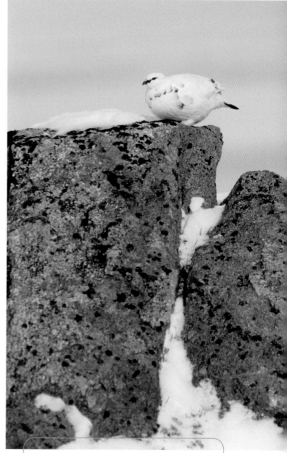

↑ *Each winter I spend some time in the Scottish mountains, photographing the native wildlife. Ptarmigan, although sometimes approachable, are often a challenge to reach when the snow is deep, but a slow, careful approach usually brings results.*

500mm lens; ISO 100; 1/500 sec at f/5.6

PRO TIP

When stalking, try not to point your lens or look directly at the bird until you are within range. If stalking a large bird, try not to shut off its escape route—remember big birds will always take off into the wind. Finally, try stalking with just your camera and tripod; don't lug your backpack with you, as this is bound to be more cumbersome.

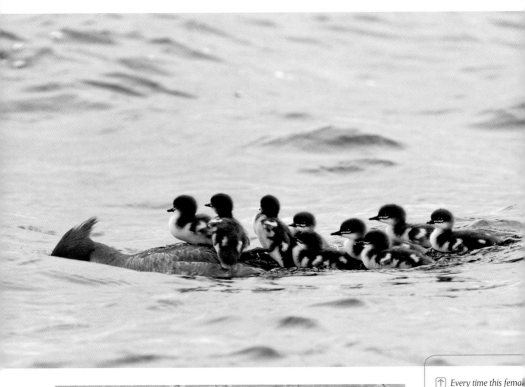

⬆ *Every time this female common merganser with her brood put her head underwater, searching for food, I moved a little closer.*

500mm lens; ISO 160; 1/350 sec at f/6.7

⬅ *I spotted this hoopoe sunning itself against the wall of a café. By moving very cautiously a little bit at a time, taking pictures as I went, I was able to get into position and shoot a number of images.*

500mm lens; ISO 100; 1/125 sec at f/16

Some birds favor particular spots in which to feed; for example, shorebirds often like patrolling a particular stretch of mud or sand. Near where I live there is a regular flock of sanderlings that feeds along the tide line. If I try to stalk them, they inevitably keep at an annoying distance for pictures; however, by sitting still, ahead of their feeding route along the shore, they will walk to within a few feet of me. This technique can work with a multitude of species; some, such as songbirds, may have favored perches from which they sing, so watch where they go, and then stake out your own perch and wait.

Playback of birdsong to lure songbirds has been discussed on page 71. Making sounds ourself can be equally effective. Making a "pish ish" noise repeatedly—known as "pishing"—is common method used by birdwatchers to ure small birds into view. It works surprisingly vell for some birds, particularly North American varblers. The theory is that it mimics a distressed ird mobbing a potential predator, which then raws other individuals to join in the attack.

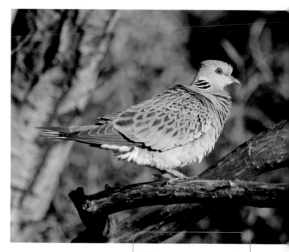

⬆ *Turtle doves are notoriously difficult to get close to, often flying large distances when disturbed. I used my car to approach this individual in Greece.*

500mm lens with 1.4x converter; ISO 160; 1/2000 sec at f/5.6

⬅ *Whenever you are close to a bird that appears not to be bothered by your presence, still stay quiet and move slowly—you want your subject to be as relaxed as possible, giving you the opportunity of capturing some natural behavior. This emperor penguin family, photographed by the Weddell Sea in Antarctica, was just a few feet away, and I still observed good field-craft skills by moving very slowly and only when necessary.*

300mm lens; ISO 50; 1/125 sec at f/8

Blinds

**Blinds have been used as a means of getting close to birds from
the very start of bird photography—more than a hundred years ago,
photographers were dressing up as cows and using all sorts of other
disguises in their quest to get close.**

We now know it is not necessary to go to such
lengths of disguise. Modern blinds resemble
simple tents with openings in them for pointing
the lens out, and they have small viewing
windows. Blinds come in various designs: some
are dome-shaped and can be erected in just
a couple of minutes, while others are tubular
constructions that may take a bit longer to put
up but are normally more rugged. There are als
blinds that allow low-level work and resemble a

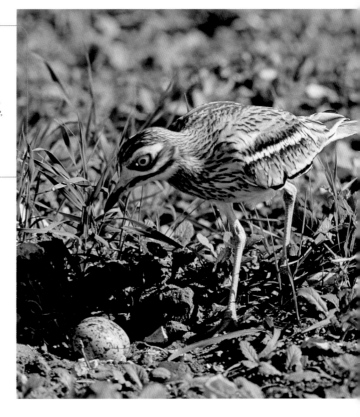

↪ *A stone curlew at her
nest, photographed from
a carefully placed blind.
To enter the blind I had a
friend to accompany me
in (known as a "putter-in"),
and when I wanted to leave,
that person came back to
accompany me out.*

500mm lens; ISO 100;
1/250 sec at f/11

ͱall tent that you lie in to shoot from one end;
ͼese are good if your subject is an early riser.

Blinds used to be employed mainly for
ͱotographing birds at the nest, since nest
ͱotography was popular due to equipment
ͷitations. Technology has improved, and nest
ͱotography is not as attractive as it once was.
ᴉ you intend to place a blind for a nest, there
ͼe a few points you need to consider. It is illegal
ᴉ photograph certain protected species in or
ͼar the nest without the relevant licenses. If
ͽu place your blind on private land you need
ͼrmission from the landowner, and it is not
ͼrmitted to erect blinds in most wildlife
ᴉuges and nature reserves.

Further points to consider include moving
in on the nest slowly over a number of days so
the birds become acclimatized. In addition, make
sure your blind is away from the public gaze—
you do not want to draw attention to a nesting
bird, and of course you do not want your blind
stolen, vandalized, or used by a courting couple!

Away from nests, blinds can be used to
photograph birds that visit a particular spot on
a regular basis: this may be your own backyard
feeding station, a drinking pool, or perhaps a

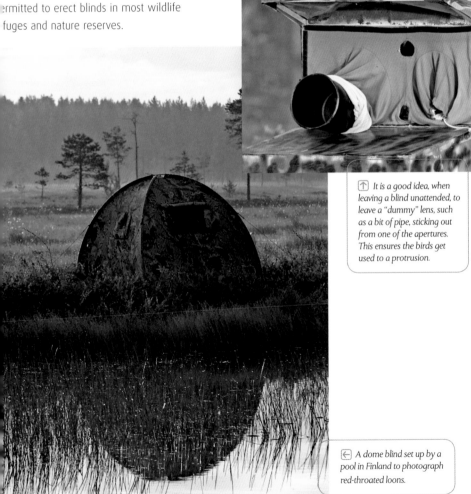

⬆ *It is a good idea, when
leaving a blind unattended, to
leave a "dummy" lens, such
as a bit of pipe, sticking out
from one of the apertures.
This ensures the birds get
used to a protrusion.*

⬅ *A dome blind set up by a
pool in Finland to photograph
red-throated loons.*

→ I used my car as a blind to photograph this black woodpecker's nest. The tree was conveniently situated right next to a forest track.

500mm lens; ISO 100; 1/125 sec at f/5.6

daytime roosting area. Bird photographers in America use blinds far less regularly than those in Europe. This is because so many species in America can be approached on foot without the need for concealment, and because many good American wildlife refuges allow entry using a mobile blind in the guise of a car. In Europe the story is very different: so many birds—especially shorebirds and wildfowl—are very timid, and blind photography can often be the only option.

When placing a blind, think about the direction of the light; there is nothing more frustrating than sitting in a blind with your bird performing in front, to find you are not quite in the right place. Think, too, about how far from the subject you want to be. Try and place the blind so that the lens you want to use will give you just the right reach. Before erecting the blind, set up your lens and experiment with distances. Find as flat a piece of ground as possible, since you don't want to be tipping in your chair, and when choosing a chair go for one with a backrest rather than using an uncomfortable stool. I always pick chairs with decent-sized feet, too, as you do not want one half of the chair sinking into soft ground.

The blind may need some extra concealment for some species; bracken or tree branches can be laid across to help break up its outline. Place a dummy lens sticking out when the blind is not in use, so the birds get used to a protrusion—this can be an old bit of plastic pipe or something similar. Depending on your subject, you may need a friend to see you in and then leave once installed. This is because most birds cannot count,

so when your friend walks away, they will think the coast is clear. Once in the blind, do not stick your lens out too far, and avoid making sudden movements; this is particularly important with very wary species, such as birds of prey. If using a blind in winter, wrap up warm and, most importantly, wear warm footwear—feet can become very cold when you are sitting still for a number of hours. Finally, don't forget a urine bottle if you need to be in the blind all day.

Many reserves have public blinds; some can be great for bird photography, while others can be awful. Talk to other photographers to seek out the good ones; most reserves have at least one blind that will prove fruitful.

Cars make great mobile blinds—many birds fail to associate danger with a vehicle, and the

↑ *This Dartford warbler sang regularly from the same perch on a gorse bush, so I placed a blind close by and simply waited for the bird to arrive and perform. I have included a reasonable amount of the bush in the frame, as the yellow flowers add color to the image.*

500mm lens; ISO 100; 1/500 sec at f/5.6

...eat thing about a car is that you can cover a ...t of ground. I use a beanbag balanced on the ...oor frame as support for my long lens, and you ...n buy window mounts (see page 32). Some ...otographers even manage to set their tripods ... in the passenger seat, although I have never ...orked out how to do this satisfactorily.

Unlike stalking on foot, when it is best to ...ove in close in stages, once you have spotted a ...rd from the car it is better to go for broke and ...eewheel up to the bird with the engine off, at ...e optimum distance for a shot. The intermittent ...ngine noise caused by stopping and starting can ...crease your subject's anxiety otherwise. Before ...ou move in on the bird, make sure you have the ...ght lens on, that your exposure is sorted, and ...at you are ready to shoot—leaving all this until ...ou are in position is a recipe for failure.

PRO TIP

Comfort in a blind is paramount, since you are likely to be spending a few hours at a time sitting still. I have mentioned the need for a decent seat, but ensure too that you are well wrapped up for winter sessions. Feeling cold, and especially having cold feet, can make a session in a blind a feat of endurance, which is not conducive to concentrating on photography.

Remote-control photography

The big advantage of using a remote-control rig, as opposed to a blind, is the ability to use a wide-angle lens and capture the bird within its habitat. Plenty of planning and fine-tuning is usually necessary to successfully take such shots, and the main requirement is a bird or birds that visit the same perch or spot regularly.

← Remote-control photography only works reliably when you can be sure exactly where your bird will perch, as here with this great spotted woodpecker on a garden feeder.

90mm lens; ISO 50; 1/60 sec at f/11

A lot of my remote-control work is done at my feeding stations, where I photograph garden birds in garden settings and on feeders; the advantage in this setting is that I can entice a bird to an exact spot or onto the feeder I want. I normally stand a little way back—or sit in a blind close by, my preferred method. Because my garden birds are continually visiting and tolerate plenty of disturbance, I can check the picture compositions on the camera's LCD regularly, until I have the desired result.

With shier species it is best to take as many images as possible. This is because, unlike viewing a bird through the viewfinder of your camera, with a remote-control setup it is difficult to judge your ideal moment for taking an image, thus your failure rate will inevitably be higher.

I fire the trigger with a wireless transmitter, which works to a range of more than 400 feet; this allows me to be a long way back if necessary. You do not have to go to the expense of a wireless outfit. Infrared triggers can be

rchased, but these do need a good line of ght and can struggle to work well in very bright nditions. You can buy very cheap triggers that tend for fifteen feet or so and are operated squeezing a rubber bulb that forces air to sh the trigger. These screw into your camera's utter button or onto the body. They can be a tle unreliable, and you need to be in a blind ry close by, but they are worth considering if ou want to experiment with the technique.

Your camera needs to be set up on a tripod use other support; I often place mine on a eanbag if taking ground-level shots. Remote hotography's wide angles mean the camera has be placed very close to where your bird will erch. This means your subject may end up being ther suspicious of the camera initially, and may ot readily use the perch. If so, you either need use a dummy camera and lens and move it to position over a number of days or use a oundproofed box, known as a "blimp." This can e a box made of plywood that fits over your

camera and is lined with polystyrene or foam. The advantage of a blimp is that it softens the sound of the shutter and will protect the camera from the elements.

Once the camera is in position, I use the depth-of-field preview button on my camera to accurately set the focus, for both the subject and background. Metering can be tricky, so I tend to stick the camera on autoexposure.

There is a high failure rate with this type of photography, but it only takes one image for the time and effort to have been worthwhile. The technique certainly produces pictures with a difference.

Traveling with your gear by air

Few of us find it relaxing to travel through airports with heavy photo backpacks. There is always the lingering danger of an overzealous official banishing our precious gear to the aircraft hold—and once in an aircraft hold, photo gear is in the lap of the gods and any number of worrying fates may await.

Unless you are using a specially strengthened case such as a Pelicase, it is imperative not to let your gear be taken from you at check-in. There are all sorts of ploys you can use to avoid this, but it is a good start to use a backpack designed to fit the maximum dimensions dictated by the airlines. I currently use a Lowepro Nature Trekker that fits these requirements perfectly and is just shallow enough to fit under a seat on most aircraft, which is very useful if you fail to find space in the overhead bins.

At check-in, you are often asked to identify your carry-on luggage; I always try and make this look as light as possible! If it does get weighed, it is inevitably well over the limit—this is always the crucial point, but I have yet to have my bag removed from me. I simply explain politely that the bag contains hugely valuable and delicate camera gear; this is normally enough, but if still challenged I point out that the gear is not insured when in an aircraft hold under my insurance policy, and so will the airline agree to cover costs if it is lost or damaged? This last line of defense always works for me; however, if one day it does not, I will be ready, wearing my jacket

with lots of big pockets so I can off-load as much as possible before the bag hits the weight limit.

Some photographers use photo vests when they are traveling and cram as much as they can into these. I have a friend who wraps his long lens up in bubble wrap and carries it in a duty-free bag, along with his regular camera bag. I can always fit all the gear I will need from day to day in my backpack, but can never fit a spare camera body, chargers, and other paraphernalia needed. I often carefully pack these items in my hard-cased suitcase, which gives adequate protection.

Obviously, insure all your equipment to make sure that anything damaged while on your trip will be replaced free of charge. In case of theft, make a note of the serial numbers, makes, and models, and consider taking digital photos of your equipment to help with identification. In the United States, registering your equipment with your local customs office is recommended. This provides you with proof of ownership and removes the possibility of having to pay import duty on your gear when you return, if customs wrongly assume you've purchased it abroad.

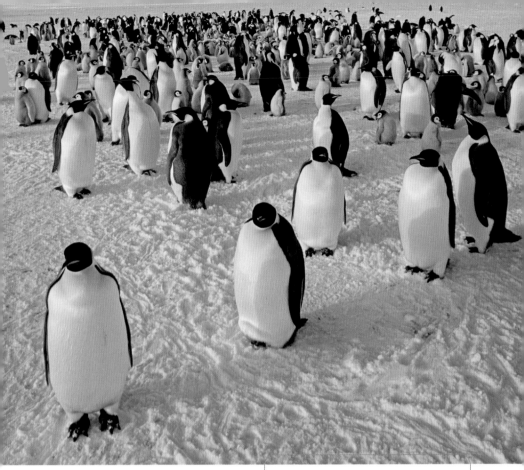

↑ *The stresses of traveling to far-flung destinations on once-in-a-lifetime bird photography trips are soon forgotten when you are confronted with great photo opportunities, such as this emperor penguin colony on the Weddell Sea in Antarctica.*

24mm lens: ISO 100; 1/250 sec at f/11

PRO TIP

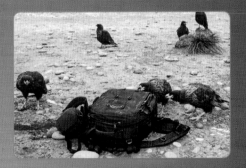

When traveling on airlines, especially in the United States where passengers carry on items far larger than those in Europe, try to be one of the first on the plane so there is space to stow your bag in the overhead bins. When bin space runs out, late-arriving passengers regularly have their carry-on luggage taken off them and stowed in the hold—a conflict you want to avoid. Here my camera bag is being attacked by some juvenile delinquents—striated caracaras or johnny rooks as they are known on the Falklands, where this was taken. I never take with me more than I can comfortably carry for at least half a day.

SETTING OFF ON YOUR OWN TO FIND AND PHOTOGRAPH BIRDS IN A FOREIGN COUNTRY CAN BE RATHER DAUNTING; SPECIALIZED BIRD-PHOTOGRAPHY VACATIONS ARE DESIGNED TO TAKE AWAY THE EVERYDAY STRESSES, ALLOWING YOU TO CONCENTRATE ON TAKING THE PICTURES

Section 2

96

Photographing birds

Choosing bird photography vacations

Years ago I would listen in awe to tales from pioneering bird photographers of expeditions to southern Spain, Lapland, and other exotic-sounding destinations. Today, such locations can be visited cheaply on budget airlines for a weekend! Not only has the ease of travel changed, but so has the flow of information on where to go to take pictures. The Internet is a big source of information for finding out about these opportunities, as is talking to other photographers.

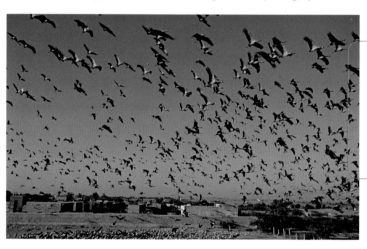

← Foreign travel can introduce you to some of the world's great bird spectacles. These are demoiselle cranes that come to eat grain put out for them by the villagers of Khichan in India during the winter.

24mm lens; ISO 200; 1/500 sec at f/11

If looking at vacations for bird photography, the best are those run specifically for photographers. There are plenty of birdwatching vacations that suggest good photographic opportunities, but these trips are set up primarily for watching birds, not photographing them. It will soon become frustrating as most of the group will want to move on to see the next bird, not giving you the opportunity to make the most of the photographic potential. Of course, if you are a sharp digiscoper, then these trips are ideal, as you don't need to wait until everyone has finished watching the bird before you move close.

Since nothing in bird photography is guaranteed, you cannot always expect success, but a lot of hard work has normally gone into setting up bird-photography vacations: food being put out daily, blinds constructed, and so on. It

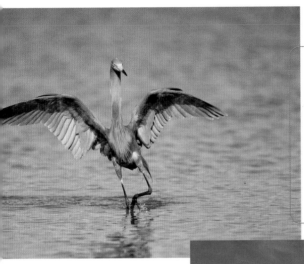

⬅ *This reddish egret photo was taken in Florida, one of the world's top destinations for bird photography. The Sunshine State is an easy destination to visit and photograph by yourself or with a group of friends, and the birds pose few problems, since they are incredibly tame.*

500mm lens; ISO 100; 1/1000 sec at f/8

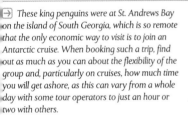

➡ *These king penguins were at St. Andrews Bay on the island of South Georgia, which is so remote that the only economic way to visit is to join an Antarctic cruise. When booking such a trip, find out as much as you can about the flexibility of the group and, particularly on cruises, how much time you will get ashore, as this can vary from a whole day with some tour operators to just an hour or two with others.*

17–35mm zoom; ISO 100; 1/250 sec at f/11

ould come as no surprise, then, to learn that any such trips are expensive. Joining a group th a leader may be the only cost-effective tion for some destinations such as Peru, Japan, the Antarctic. This brings many benefits: the st is brought down from that of independent vel (or at least it should be); you have a der who can assist with your photography, it should be a learning experience; and the portunities should be set up so that you don't ed to find the birds or figure out other logistical oblems on your own.

When choosing a trip, check that your leader ows the destination well. Try also to chat with photographers who have been before, or to the leader to get a feel of how the trip will be run—if you are spending a lot, you want to make sure opportunities will be maximized. The best companies are those that pay their leaders well; some refrain from paying, stating that a free trip is payment enough. If you are aware of such a setup, I would think twice about investing, as it is likely your leader may well be more eager to take pictures for his own gain rather than helping his clients.

Finally, it is easy to visit many destinations on your own or with like-minded friends, such as Florida or Lesbos in the Greek Islands.

THE RESULTS OBTAINABLE FROM A COMPACT DIGITAL CAMERA LINKED TO A TELESCOPE
CAN BE TERRIFIC AND NOT POSSIBLE ON EVEN AN EXPENSIVE DSLR. ALTHOUGH THE
SYSTEM BRINGS ABOUT ITS OWN WAYS OF WORKING, THESE TECHNIQUES STILL TAKE THEIR
CUE FROM STANDARD GOOD PRACTICE.

Digiscoping techniques in the field

Due to the limitations of following fast-moving birds in the viewfinder
with a digiscope, photographing active subjects, such as warblers and
other small birds, can take a lot of practice. Even so, all birds stop and
rest occasionally to preen or look around, so you need to stay alert
and be patient. If you are new to digiscoping, it is worth starting with
shorebirds or larger, less-active species.

Set the various parameters on your compact
camera before you start shooting; these include
sharpening levels, the white balance, the ISO,
and selecting what JPEG quality is best. Most
compacts perform poorly at high ISO settings
compared to DSLRs, due to their small chips
and inferior processing algorithms; this means

⬇ A shutter-release cable is
a necessity when digiscoping.

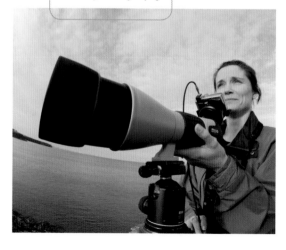

that noise can be a problem above ISO 200. It i
advisable to switch off the ISO auto setting and
leave it on its lowest setting, probably 100.

Like DSLR users, most digiscopers set their
white balance to auto, and this works well 99
percent of the time. Setting your metering is a
personal preference, but spot-metering on the
autofocus area is common among digiscopers. I
would suggest leaving your image sharpening c
"normal," as you can always sharpen in Photosho
if necessary. Image quality should be set at the
finest setting, normally referred to as "fine."

As mentioned previously, there is no substitu
for a good, sturdy tripod. This is absolutely essent
for digiscopers, since the high magnifications yo
will be shooting at magnify any shake, creating
blurry pictures. If camera shake is a problem,
try kneeling with the tripod legs folded to their
lowest working height, particularly if it is very
windy. When using very slow shutter speeds, a
cable release will help—if you have a rock-solid
tripod and no wind when using a cable release,
shutter speeds as low as 1/15 sec should
achieve sharp results, as long as your bird is no

↑ *A Eurasian curlew
digiscoped from my car.
I rested the scope on a
beanbag on the door frame.*

Coolpix 9500 with Nikon
Fieldscope ED82

oving. If you don't have a shutter-release cable,
 the self-timer, although this method has to be
ed in the hope that the bird is aware it is not
owed to move! The decision-making processes
 choosing shutter speed and aperture are the
me as for conventional photography.

As with conventional photography, the
tofocus on your camera may sometimes hunt
 t cannot find enough contrast, so be aware of
s and move your focusing point on the bird
his creates a problem. The camera's focus
firmation will help in sharp focusing.

In bright conditions, monitor shades can be
aluable. Nikon makes a handy little shade that
slips over the Coolpix monitor, which you can
keep in a pocket or attached to the camera so
it is always handy.

Heat haze can be a big problem when you
are some distance from the bird. On hot days,
try to avoid shooting across tarmac or other
substrates that soak up and so give off lots of
heat. Of course, heat haze is difficult to combat
during the middle of the day, so shooting early
or later on can help.

PRO TIP

Finding birds in the viewfinder can be tricky
at high magnifications. First, find your bird
at the lowest zoom setting and then zoom
in to take your picture.

WHEN YOU START PHOTOGRAPHING BIRDS, YOU MAY HAVE A CLEAR IDEA OF WHAT YOU WANT TO SHOOT AND HOW YOU WANT TO SHOOT IT. HOWEVER, BY REGULARLY REVIEWING YOUR GOALS AND KEEPING AN EYE OUT FOR UNEXPECTED OPPORTUNITIES, YOU GIVE YOUR CRAFT EVERY CHANCE TO IMPROVE IN WAYS THAT YOU MIGHT NOT HAVE ANTICIPATED.

In the field—
a personal experience

For many years, my constant aim when I set off on bird photography trips was to shoot as many different species as I could. This worked well for me and gave me a great deal of satisfaction. However, in the back of my mind I often had a lurking feeling that many of my shots might have been compromised in my quest for variety.

This approach fundamentally changed when, in spring 1988, I attempted to photograph a drake king eider on the Ythan Estuary, north of Aberdeen in Scotland. I spent two whole days taking images of this bird, but there was one particular shot I wanted: the bird's colorful head poking above a breaking wave in the foreground. After much persistence I finally got my shot, and I realized from that day on that if I had a vision of an image, it was possible to go out and work at it until I captured it.

↑ *My aim is always to try and design an image, rather than aimlessly snapping away at my subjects. I purposely included just part of the closest arctic tern in this image—less is often more.*

10.5mm lens; ISO 200; 1/800 sec at f/11

→ *This image of a king eider fighting through the waves, taken almost two decades ago, changed my approach to photographing birds. I realized that with perseverance I could achieve the images I had preplanned in my imagination.*

600mm lens; ISO 100; 1/250 sec at f/5.6

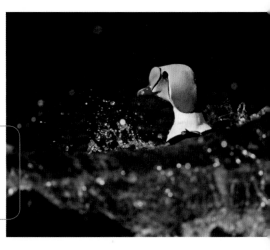

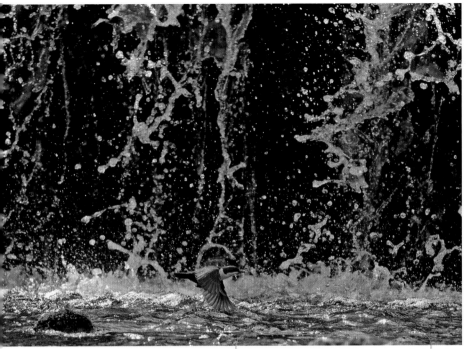

Ten years later saw me joining an expedition the Weddell Sea in Antarctica to photograph peror penguins. This trip lasted almost a nth and was an endurance test on mind, body, d equipment. For ten days I became totally mersed in photographing the penguins, and me away with a body of work that won a mber of awards. To this day, these images main some of my finest pieces. This too was a tershed in the way that I worked, and since n I have put all my energies into acquiring as ep a coverage of a species as I can.

I have found that by putting time and effort being in the field, great opportunities present mselves, and image concepts can be worked at d achieved. A more recent image that illustrates s is that of the flying dipper on page 100.

Dippers fly very fast, so they are hard to ture in flight using conventional techniques. ecided to photograph dippers along a stretch river in Derbyshire, England, one spring,

and spent a number of days on the riverbank working with the birds. I wanted to illustrate the dipper within its habitat, and one afternoon when I noticed a dipper fly across the face of the waterfall, I knew then that this was the shot I wanted. I then stood for around eight hours every day for the next three days, firing off shots as the occasional bird flew in front of the falls. Most opportunities ended with the bird flying at the wrong height or veering off-course at the last moment. Eventually, however, everything came together and I bagged my shot; my doggedness to get the shot had worked.

For me, one of the great thrills of shooting in the field is not knowing what opportunity will come my way next. I expect the unexpected, and just hope to be ready for it.

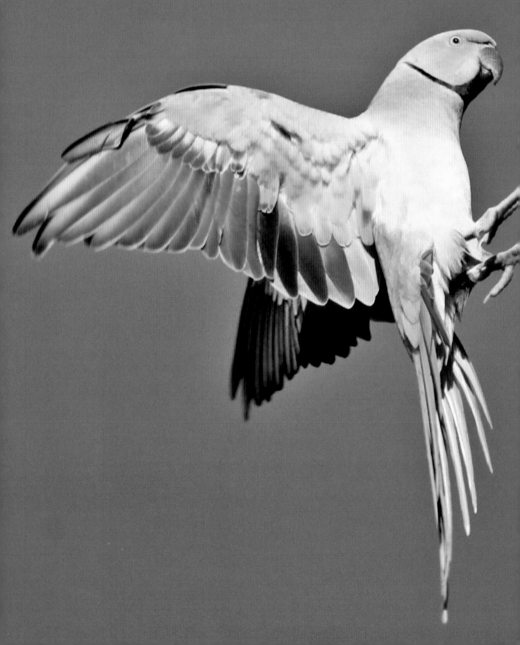

Digital photo editing

Welcome to the digital darkroom! This section of the book shows you what to do with your images once they enter the computer—how to improve how they look, tricks of the trade for improving composition, and how to become an eye doctor, too.

the mid-1980s, bird magazines were still predominantly printed in black and white, and I and many of my peers were shooting in is medium as well as in color. I started out sing black-and-white film and had to learn the ays of the traditional darkroom. Photography now dominated by color and computers, but ill we have a darkroom to work in—in the form computer imaging software. As in the days of ack and white, learning how to optimize our ages is just as important as learning how to ke them in the first place.

One of the reasons many bird photographers ng on to using film for so long, when the vantages of digital were obvious to see, was ndoubtedly the apprehension of entering the nknown. If computers are new to you, digital aging can offer a steep learning curve. This allenge is less daunting, however, when you alize many of the processes are all about using mmon sense and judgment as to what you ink looks right on the screen.

As mentioned in the introduction, all the processes follow the latest version of Adobe Photoshop. However, if you are a Photoshop Elements user or use other software, both the tools and processes in these are either similar or in many cases identical, so you should have no problem following the directions.

⬇ *A preening anhinga, photographed from the anhinga trail in the Florida Everglades.*

500mm lens; ISO 100; 1/250 sec at f/11

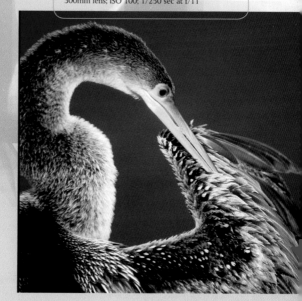

⬅ *This ring-necked parakeet flying into its nest hole in Richmond Park in London was one of my first digitally captured images.*

500mm lens; ISO 200; 1/2000 sec at f/4

AS IF THE ADVANCES IN DIGITAL CAMERAS AREN'T ENOUGH TO CONTEND WITH, COMPUTERS AND SOFTWARE SEEM TO BE UPGRADED EVERY WEEK. TO NAVIGATE THIS TECHNOLOGICAL JUNGLE, IT PAYS TO BE CLEAR ON THE FEW BASIC REQUIREMENTS THAT WILL ENABLE YOU TO STORE AND MANIPULATE YOUR IMAGES.

Computer hardware

If you have a computer or are intending to buy one, you need to ensure it will be up to the task of dealing with your pictures. This means having plenty of RAM (random access memory) and a decent processing speed.

RAM is used to run the programs in your computer and is where your images go when being viewed and manipulated; in effect, it is a temporary storage area within your computer. RAM is easy to add to a computer if you already have an existing machine; if not, make sure your new computer ends up with at least 1Gb (gigabyte) of memory—you should really load on as much as you can afford.

The next issue to examine is hard drive space a minimum of 250Gb with an 8Mb (megabyte) disk cache gives both speed and good capacity.

⤓ *There is a huge choice of computer hardware available, and it is wise to research your purchase carefully beforehand. One of your main choices will be whether to go for a Mac or a PC. This is the Power Mac G5 setup.*

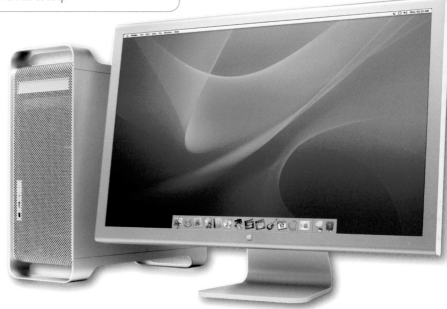

→ *I always travel with a laptop, since it is very useful to get back to where I am staying and check the pictures I have shot that day. This pair of great blue herons was taken at the Venice Rookery in Florida. The bird stretching its wings is a fledgling.*

600mm lens; ISO 100;
1/800 sec at f/5.6

← *Your computer opens the door to a new way of making eye-catching images. I have played around with the colors and contrast in this image of a nesting kittiwake in the center of Newcastle to create a slightly more abstract-looking image.*

ou take lots of pictures, your hard disk will soon e groaning under the strain, so, as with RAM, ore is better. Whether you go for a PC or Apple acintosh system is a personal preference. Adobe hotoshop, the imaging software you are likely to se, works equally well on either system.

If you are really serious about your hotography, an important consideration is the uality of monitor you use to view and enhance ur images. Consumer monitors are fine for ewing images, but chances are you will want use a screen that displays your images at the otimum resolution and that can be calibrated to nsure its colors are displayed accurately. There re two types: the CRT (cathode ray tube), and

LCD (liquid crystal display); the latter flat-screen type is without flicker, has less glare, and takes up less space. Whichever screen you decide to go for, you should try for a minimum screen size of seventeen or nineteen inches. The bigger the better here, and not just physically, but in terms of pixels too; a nineteen-inch screen with 800 x 600 pixels is not as good as a nineteen-inch screen with 1280 x 1024 pixels.

Finally, a word on laptops: they are very popular with traveling photographers, and the latest models from Sony and Apple have excellent screens, too. One thing to remember when viewing images on laptops is their narrow angle of view.

THERE ARE OTHER EDITING PROGRAMS ON THE MARKET, BUT PHOTOSHOP IS THE MARKET LEADER, AND FOR GOOD REASON. REMEMBER THAT NO MATTER HOW GOOD YOUR EDITING SUITE, IF THE COLORS ON YOUR MONITOR ARE NOT ACCURATE, YOUR RESULTS WILL DISAPPOINT.

Editing software and working with color

Once you have transferred your images from camera to computer, you need a way of organizing, editing, and optimizing, before finally storing them for future use. Adobe Photoshop is the top choice— indeed there are no rivals for what it offers. At first glance it is a daunting program, yet you only need to learn a few simple Photoshop procedures to effectively enhance your images. You will find that as your experience with the program develops, you delve deeper and discover new, exciting tools to develop your creativity.

↑ *Calibration devices fit onto the screen and match the screen representation to Pantone-correct colors. This is a specialized Sony calibration monitor, where the device comes ready-fitted.*

There is a basic and inexpensive version of Photoshop, called Photoshop Elements, that will do all you need for basic image adjustments. However, if you can afford it, go for the full, professional version—at the time of writing this is CS2. This will allow you to develop your skills as you progress, and when new versions of Photoshop are released with developments that may be useful, then you can upgrade easily.

The alternatives to using Photoshop are camera manufacturers' software: Canon and Nikon both produce their own, and Apple offers Aperture, which is designed for use on Apple Macintosh computers and aimed at professional photographers. It is focused on the RAW work flow and offers an all-in-one postproduction tool. Adobe's new tool called Lightroom also manages RAW workflow and is well worth considering. Aperture and Lightroom will, for many photographers, offer an alternative to using the full version of Photoshop, as these new tools are designed specifically for photographers.

To get good, consistent results, whether printing your images or sending them to others to view, you need to be able to trust the colors you see on your screen; this is color management. Color is a subjective thing, and if you regularly watch birds you will know how lighting during different times in the day affects the colors of the birds we view, so you may be forgiven for wondering whether color management actually matters to you. But do you want to produce prints that consistently replicate what is displayed on your screen? Do you want to display on your screen the colors that you saw in the bird you photographed accurately? If the answer to these two questions is yes, you need to color-manage both your monitor and printer.

Using the display calibrator is a big step in the right direction for calibrating a Mac monitor. If you are a Windows user, Adobe Gamma, which ships with Windows versions of Photoshop, will do the same job. This software is found in *Preferences > Control Panel* and adjusts the brightness, black, white, midpoints, color temperature, and sets the gamma. If you do nothing else, this will help at least.

To be really accurate with color, you need to use a Colorimeter or spectrophotometer. These are devices that attach to your monitor's screen and read colored targets, generating a color profile known as an International Color Consortium profile (ICC). Having these profiles as standards means all devices color-calibrated in this way can speak the same color language. This means that if you send a picture to a friend's computer, and both your monitors are color-calibrated, the image should appear as a very close match.

Consider your work setup too. Avoid direct sunlight spilling across your screen or very changeable light conditions within the room. Subdued lighting is best for accurately gauging the adjustments you make to your images; I use a hood on my screen to cut down on reflections.

Finally, you should ensure that if you are capturing your images in the Adobe RGB (1998) color space; this same color space should be set to Photoshop or whichever software you decide to use.

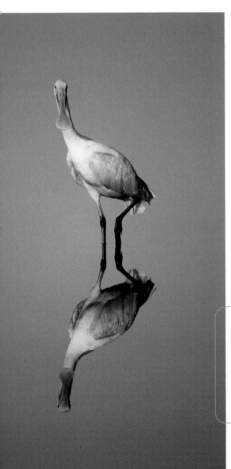

⟵ *Color accuracy is important: the subtle pinks of this roseate spoonbill could look very different from reality on a monitor that is not calibrated.*

500mm lens; ISO 100; 1/250 sec at f/11

EVERY PHOTOGRAPHER WHO USES DIGITAL MEDIA HAS, AT ONE TIME OR ANOTHER, LOST IMAGES ON A MEMORY CARD OR DELETED IMAGE FILES ON A COMPUTER. ONCE DONE, THE PAIN OF THE LOSS MEANS YOU MAKE SURE IT DOESN'T HAPPEN AGAIN, BUT BEST TO LOWER THE ODDS OF IT HAPPENING IN THE FIRST PLACE.

Importing and editing photos

Once back home from a shooting trip, you need to download your valuable images to a computer. There are various methods of doing this; perhaps the most obvious way, but one to avoid especially with DSLRs, is downloading directly from camera to computer via a USB port. This is a very slow method, and I would suggest it only as a last resort.

It is better to use a PC card adapter, which allows CompactFlash cards, Secure Digital, and IBM Microdrives to be inserted into a PC card slot on a laptop or PC card reader. The images can then be transferred to a folder. Or you can use a card reader. I use a Universal Card Reader plugged into my computer, into which my CompactFlash card is inserted for a swift download of images.

↑ I use Bridge, Photoshop's file browser, for quick editing once images are downloaded into my computer.

→ The slide show, found under View in Bridge and found in many other file browser programs too, is an ideal way of editing your images.

Adobe Bridge Slideshow Commands
Press the H key to show or hide these commands

General

Esc	Exit Slideshow	Space	Pause/Play
L	Loop on/off	W	Window mode on/off
C	Change caption mode	D	Change display mode
S/Shift+S	Increase/decrease slide duration		

Navigation

| Left Arrow | Previous page | Right Arrow | Next page |
| ⌘+Left Arrow | Previous document | ⌘+Right Arrow | Next document |

Editing

[Rotate 90° counterclockwise]	Rotate 90° clockwise
1 - 5	Set rating	6 - 9	Set label
, (comma)	Decrease rating	. (period)	Increase rating
0	Clear rating	' (apostrophe)	Toggle rating

1.4.1c.tif

10/10/2005, 12:00:09 pm

Most digital cameras come with some kind of editing software. This is Nikon's PictureProject.

Once your images are safely on your computer, you can ready your card for reuse by formatting it. This wipes it clean. If you happen to do this by mistake and lose images, there is retrieval software available. Lexar CompactFlash cards contain Image Rescue software, and some other brands ship with a CD that can be used for retrieval. Alternatively, there are many Web sites on the Internet offering solutions.

Once you have downloaded your images to a folder, you need to take a critical look at them to do an initial edit and discard any obvious howlers. Because I use Photoshop CS2, I use Bridge. This is Photoshop's file browser, and it offers a powerful means of editing. This and many other software programs provide a slide-show facility, and this is my preferred way of editing quickly. By passing the images through the slide show, those that are unsharp or inadequate in other ways can be deleted, until you finally end up with a selection to be processed and eventually archived.

Do not get too ruthless in your editing, because it often pays to revisit images at a later date to take another look. It is surprising how your attitude can change toward an image over the passage of time. I sometimes look back at images taken years ago, which at the time I was not keen on, and suddenly see them in a different light. Perhaps this is often because a fresh memory of looking at a bird through the viewfinder doesn't compare well with then viewing it on screen. I never cull images that are technically perfect or reasonably composed, since although I might not choose to process them, I may have a use for them in the future.

PRO TIP

Once you have completed your edit, it will help to get into the habit of renumbering your images to follow whichever system you use. You do not want to end up with images on your hard drive with the same sequence number. This will happen unless you renumber, because DSLRs reset themselves once they reach a limit, normally 9,999. When renumbering, limit yourself to a total of eight characters whether numeric or alphabetic in total. This is because some environments do not support file names in excess of eight characters, so you might send someone an image with more than eight characters in the file name and find it cannot be read by their machine.

Processing a RAW image

If your camera allows you to shoot in RAW, then I would strongly urge you to do so. While it is more time-consuming to deal with a RAW image, you do have far greater control over the final result.

To open a RAW image you need a RAW converter. This is built into Photoshop for most makes of camera, and is called Adobe Camera Raw (ACR). A few require a software plug-in that can be downloaded for free from the Adobe Web site. While I use Adobe Camera Raw, you will hear other photographers championing other third party converters; they include Breeze Browser, Capture One, and Bibble to name just three. However, I have no complaints with ACR, and when used in conjunction with Photoshop's file browser Bridge, it is very suited to my workflow.

ACR is illustrated here, but other RAW converters will have similar if not identical tools, so my suggestions are applicable to these too. The settings in ACR should show your color space. This is likely to be Adobe RGB (1998); you should be working in 16-bit per channel, and you will need to also set your resolution. Mine is set at 300ppi (pixels per inch), as this is the common output for print. The *Size* box allows you to reduce or enlarge the size of your image. If you know you will need a 50Mb file for a very large print, then you can make the file size bigger (via interpolation), rather than interpolating in Photoshop.

A number of tools run along the top of the screen. On the left, the *Magnify* tool will, when double-clicked, enlarge the image to 100 percent while next door, the *Hand*, when double-clicked, will restore the image—this tool can be used to scroll around an enlarged image on-screen. Other useful tools include a *Crop* tool, a *Straighten* tool, and tools to rotate the image. On the right are three boxes that are useful to keep checked off; *Preview* allows you to see adjustments you are making to the image as you do them, and *Shadows* and *Highlights* show you to any clipping in either of these, shown as bright red in the highlighted areas and blue in the shadows (see page 39 for further information on clipping).

Down the side are the tools you will use to optimize your image—try and do as much as you can in ACR, to minimize work in Photoshop. If you have made a good exposure in the first instance, then you need make only minor adjustments in Camera RAW and very little in Photoshop. If you find yourself having to do a lot of adjusting, the picture is likely to be poorly exposed in the first place. It pays to be cautious when adjusting any image using *Saturation*, *Contrast*, and *Exposure* in both ACR and Photoshop.

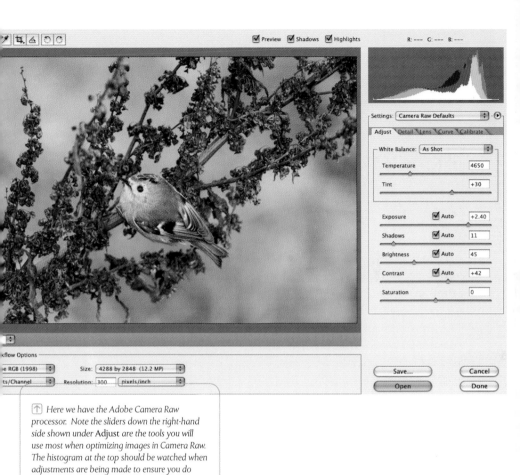

○↑ Here we have the Adobe Camera Raw processor. Note the sliders down the right-hand side shown under **Adjust** are the tools you will use most when optimizing images in Camera Raw. The histogram at the top should be watched when adjustments are being made to ensure you do not overadjust and blow highlights or lose detail in blacks.

Starting from the top and working down, the *Settings* panel allows you various options. have this set to *Image Settings*, since this splays the image as shot in your camera. e drop-down menu gives you further options; have the *Auto* adjustments checked to give R's best guess as to how the sliders below ould be set and to give you the optimum sult—a very useful starting point for working the image.

Starting with the tabs, *Adjust* is the one u are likely to use most, as it contains the ain controls. These include *White Balance* d *Tint*; the ability to control white balance

PRO TIP

If you work on a Mac, you might want to consider using Aperture. Designed for photographers, this RAW processor is a very effective tool for both fast editing and increasing the speed of your workflow when optimizing RAW images. Adobe's Lightroom program offers similar functions and is available for both PC and Mac.

is good enough reason alone to shoot in RAW over JPEG if you have the option. The *Temperature* controls how warm or cool the image looks, while *Tint* controls the magenta and green components in the image. The *Exposure* slider gives a range of eight stops, four either way. Take great care when using this tool, and keep an eye on the histogram at the top to avoid too much clipping.

Below this is the *Shadows* slider; when using this, again keep an eye on the histogram, or, if you have the *Shadows* box checked, you can identify any clipping from the appearance of blue in shadow areas. *Brightness* is self-explanatory, though you might find that increasing or decreasing brightness in Photoshop using *Curves* (see page 118) is a better option. The same applies with *Contrast*: I tend to leave this adjustment until the image is in Photoshop, and I then adjust it in *Curves*, where very fine and localized adjustments can be made. Finally, *Saturation* is another slider that requires care

in its execution—I rarely, if ever, go above a plus value of 25 when increasing saturation; generally, the smaller the adjustment the bette as you can push colors out of their gamut if you are too heavy-handed.

Next to the *Adjust* tab is the *Detail* tab. *Sharpness* is set at a default of 25, which I leav on to help lessen the softening effect many DSLR chips create. (Sharpening in ACR should not be confused with sharpening in Photoshop for output.) *Luminance Smoothing* helps reduce luminance noise, which shows as variations in brightness within tones, while *Color Noise Reduction* helps reduce noise that often appear as random-color pixels in darker tones. If you need to use these tools, it is best to use them with the image enlarged to 100 percent on you screen, so you can monitor the effect you are adding closely.

The *Lens* tab is home to the *Chromatic Aberration* and *Vignetting* sliders, but if you use decent lenses you may never have to use these

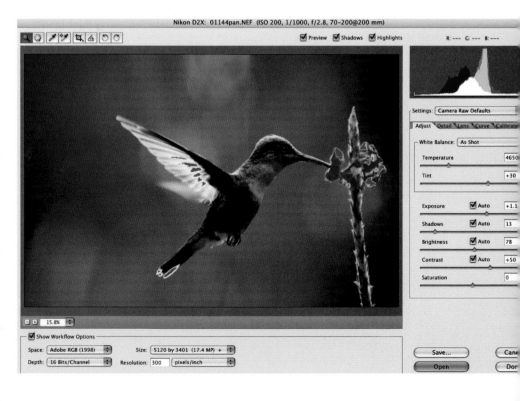

ls. Chromatic aberration is color fringing,
en caused by older lenses, while vignetting is
darkening of the corners of an image, often
used by using a wide-angle lens not designed
that particular DSLR.

The *Curve* tab is perhaps the most
allenging tool to use effectively, but it is
o one of the most powerful, and is ideal for
ectively adjusting contrast in the image. For a
explanation of how to use Curves, see page
0. Finally, the commands under the *Calibrate*
can be used to make settings that rectify
or casts created by your camera: for example,
ne Canon cameras deliver images with a
agenta cast, so by setting these sliders you
adjust for such abnormalities.

At the bottom are three buttons. *Save* saves
justments and offers the opportunity to do
ch renaming with the files you have worked
in ACR. The *Done* button applies the changes
u have made to the metadata (adjustments
u have made) but does not open the image

in Photoshop. *Open* applies the changes and
opens the image in Photoshop.

One final point: as long as you start with
a 16-bit image, you will want to do any other
adjustments in Photoshop in 16-bit also; only
when all your adjusting is done do you want
to reduce to an 8-bit image. This is because a
16-bit image contains much more color
information, so that by doing adjustments in
16-bit, your changes to color information are
far more subtle than if you were to make the
changes in 8-bit, where there are far fewer
color values.

⟵ ⟱ *Here is an image of a female violet-crowned wood nymph hummingbird in the RAW converter. Note that the red-shaded areas denote blown highlights, which have been mainly rectified in the bottom screen shot after I've worked on it. The first screen shot shows the* **Adjust** *tool palette, with the* **Auto** *boxes checked off. The second shot illustrates the* **Curves** *palette, which is where I made most adjustments.*

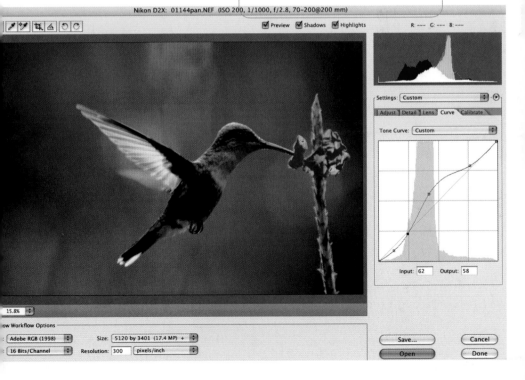

Nikon D2X: 01144pan.NEF (ISO 200, 1/1000, f/2.8, 70-200@200 mm)

OF COURSE YOU WANT TO GET THE COMPOSITION OF A PHOTOGRAPH RIGHT WHEN
YOU ARE TAKING IT, BUT SOMETIMES THIS ISN'T POSSIBLE, SO A LITTLE SENSITIVE
CROPPING IN PHOTOSHOP CAN MAKE ALL THE DIFFERENCE. CROPPING CAN ALSO
MAKE A GOOD COMPOSITION EVEN BETTER.

Improving composition

Most pictures you take benefit from a little cropping. How you crop is very much down to your individual taste, but think about composition and experiment with what feels pleasing to your eye and what does not. In most instances, if you are showing the whole bird in the picture, you need to give it room to breathe—cropping too tightly can be a big turnoff.

You can crop your image inside the RAW converter or in Photoshop; whichever you choose, you will probably want to test cropping most images to see whether it improves the overall composition. It is, of course, better to take care to carefully frame and compose in the first instance when photographing. If you rely on doing this with the *Crop* tool in Photoshop, you are immediately discarding some of the image, thus making the overall file size smaller. This can be

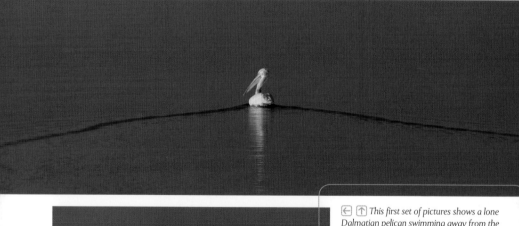

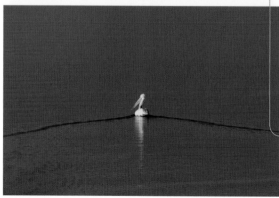

← ↑ *This first set of pictures shows a lone Dalmatian pelican swimming away from the camera. The main elements in the picture are the bird and the wake the bird leaves as it swims. The original image has a lot of wasted space above and below the bird, so by using the* **Crop** *tool, I have created a panoramic-shaped image, which helps concentrate the eye to give a more pleasing composition.*

500mm lens; ISO 160; 1/1000 sec at f/8

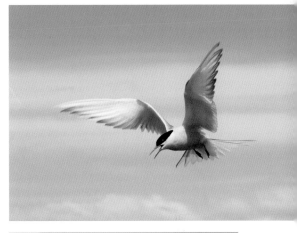

A pair of Dalmatian pelicans this time; ~~f~~or some reason I placed the birds to the right in ~~t~~he original image. Once displayed on my monitor, ~~I~~ decided I did not like the off-center position of ~~t~~he birds, so I reframed the pair to give a more ~~b~~alanced image.

~~3~~00mm lens; ISO 160; 1/500 sec at f/8

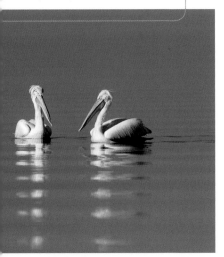

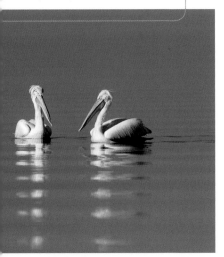

This arctic tern is looking left, while to its right there is too much empty space to allow the picture to feel balanced. Therefore a simple crop to remove some of this superfluous space immediately improves the image.

70–200mm zoom lens; ISO 125; 1/800 sec at f/7.1

~~m~~ajor drawback, as it will limit how much you ~~can~~ enlarge your image before it pixilates.

I regularly crop images into the panoramic ~~form~~at if I feel this is warranted. This is ~~par~~ticularly useful if your bird is fairly small in the ~~fra~~me and there is a lot of uninteresting space ~~abo~~ve and below the bird; by cropping in this ~~wa~~y you can place emphasis on your subject ~~whi~~le retaining background interest.

Take a look at the examples of the crops ~~on~~ this page: you will soon get a feel for what ~~loo~~ks right. Cropping can be a fun part of post-~~pro~~cessing, particularly when you experiment and ~~find~~ a crop that suddenly elevates your image to ~~a fa~~r better picture than the one you started with.

PRO TIP

When cropping a picture, experiment with different crops and don't be afraid to be radical sometimes. If your file size is big enough, try cropping in on the head of a large bird, or perhaps another part of the bird, to create a more abstract image. If you wish to sell your work, then keep your cropping to a minimum; one of the biggest causes of designers discarding images is too-tight crops, giving them little room to play with when fitting a page design over an image.

EXPOSURE, CONTRAST, AND COLOR ARE THE FIRST BASIC ADJUSTMENTS TO BE MADE TO
AN IMAGE IN THE COMPUTER. TO AVOID MANIPULATING AN IMAGE ONLY TO FIND THAT YOU
CAN'T START AGAIN, ALWAYS KEEP AN UNTOUCHED MASTER COPY OF THE ORIGINAL.

Adjusting exposure, contras and color in Photoshop

**If you are not shooting in RAW, then you will want to make your basic
adjustments in Photoshop, and the main one you may wish to make
will be improving a poor exposure. As with many actions in Photoshop,
there are various ways of doing this. If you are dealing with a JPEG, the
first thing you should do is make a copy, so you have a master copy to
fall back on if your experiments turn out badly.**

When making corrections in Photoshop, you
should always work in layers. A layer is a way
of placing a filter over the surface of your image,
so that when you make adjustments you can
see the difference you are making but the pixels
in your image are not physically altered. This
means you can do any number of adjustments in
whichever layer you choose at any time without
being destructive to the building blocks of the
image. Once you have made all your adjustments
in layers, you will have a big file due to the
extra layers added to the original image, so to
reduce the file back to its native size you must
remember to flatten the image by clicking
Layers > Flatten.

Under *Layer > New Adjustment Layer,*
there is a drop-down menu from which you can
choose various options. Try and steer clear of
Brightness and *Contrast*, as all adjustments you
make with these tools risk compromising image
quality, since they work rather crudely. If you are
working in Photoshop rather than Elements, it is
far better to make these adjustments in *Curves*
(See page 120).

Levels makes a good first port of call. This
allows contrast, color, and image brightness to
be adjusted by using a simple slider. The *Levels*
palette illustrates, by way of a histogram, the
distribution of pixels across the entire tonal ran
from black on the left to white on the right. Th
function is like the histogram found on the bac
of your camera when you check for exposure,
the difference being that you can adjust these
histograms. Contrast and exposure can be fine-
tuned in *Levels* by means of the triangular slide
arranged along the bottom of the histogram. Yo
aim is to spread the tonal values in the image
much as possible; if you set the brightest pixel
to white and the darkest pixel to black you will
increase the amount of image contrast you hav
to work with without losing any information.
To do this, move the sliders on either end in to
meet the start of the graph. To make an accura
adjustment and to avoid clipping, hold down Al
(Opt)—the screen will go black for the *Shadow*
slider and white for the *Highlights*. When movi
the sliders in, stop as soon as you see clipping
occurring in the form of the bright blue and rec

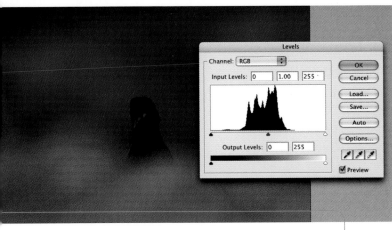

Here we have an image of a black guillemot that is slightly too dark: I have underexposed by a ...d or half a stop. The levels palette is my first port of call—this shows the pixels bunched in the ...ter and to the left, and there's a gap between the pixels and the edge of the histogram. Because ...histogram does not meet the slider on the right, this means the contrast is low, so we need to ...rease this by dragging the slider in to the start of the histogram. You can see the improvement ...t has been made in the next screen shot, which looks flat due to a lack of contrast.

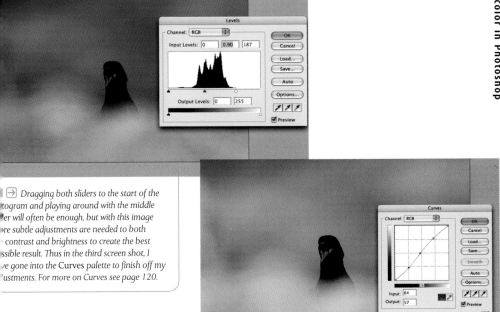

*➔ Dragging both sliders to the start of the ...togram and playing around with the middle ...er will often be enough, but with this image ...re subtle adjustments are needed to both ... contrast and brightness to create the best ...ssible result. Thus in the third screen shot, I ...ve gone into the **Curves** palette to finish off my ...ustments. For more on Curves see page 120.*

...eas appearing. Once this has been done, you ...n brighten or darken the image using the ...iddle slider.

You can make even more subtle adjustments ...colors in *Levels* by clicking on the drop-down menu under *Channel*. Individual colors can then be adjusted, perhaps to correct for a color cast, for example. Color can also be adjusted in *Hue/Saturation*, but be careful not to overdo adjustments with this tool.

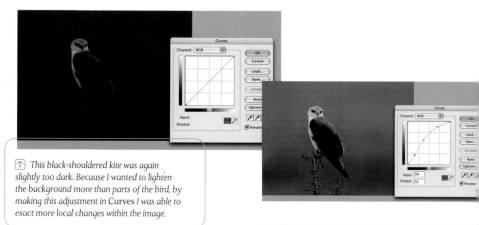

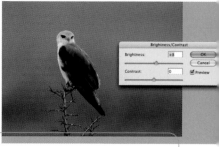

↑ This black-shouldered kite was again slightly too dark. Because I wanted to lighten the background more than parts of the bird, by making this adjustment in Curves I was able to exact more local changes within the image.

↑ The same image, but this time I have used the Image > Adjustments > Shadows/Highlights tool to do the same job. This tool is often a quick fix, which, if you are struggling to come to terms with using Curves, will do the job for you with minimum fuss.

↑ I have alluded to the fact that using the Brightness/Contrast tool (Image > Adjustments > Brightness/Contrast) is often not the best way to brighten or increase the contrast in a picture, because these tools are rather crude compared to using Curves, where you can make more local adjustments. However, having said all this, using this tool in small doses can be the answer to making a needed improvement.

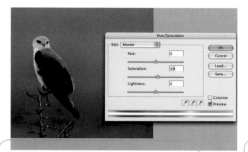

↑ Another tool that should only be used in small doses, the Hue/Saturation (Image > Adjustments > Hue/Saturation) tool, is the most useful slider in this palette for helping to pump up an image's colors a little.

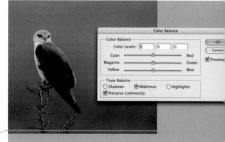

↑ You are unlikely to need to use the Color Balance tool (Image > Adjustments > Color Balance) very often. But if you decide you have a color cast or want to subtly adjust the colors in part of an image, then you can experiment with this palette.

PRO TIP

This great tinamou, photographed along the famous Pipeline Road in Panama, just needed some minor corrections. I increased the contrast and lightened the whole image a little by using the *Curves* tool, then made a minor color adjustment. The changes are subtle but they do improve the overall feel of the image.

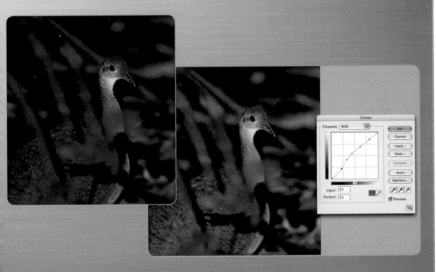

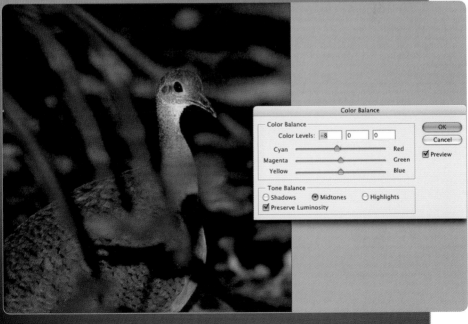

THE *LEVELS* HISTOGRAM IS THE FIRST STOP FOR CHECKING BRIGHTNESS AND CONTRAST IN A IMAGE; *CURVES* IS THE SECOND AND BY FAR THE MOST POWERFUL. USED WITH CARE AND (ADMITTEDLY) A LOT OF PRACTICE, IT WILL BECOME AN INVALUABLE TOOL.

Using Curves

Using *Curves* can seem like a daunting proposition, and of all the adjustment tools in Photoshop, it is perhaps the hardest to master. However, it is a very powerful application, and well worth getting to know. Individual tonal values and brightness and contrast can be adjusted in *Curves*. The default graph displays a straight line running from dark tones in the bottom left to light tones in the top right.

Play around in Curves at first to see the effects created by dragging the line up for lightening the image and down for darkening it. Shadows can be darkened or lightened by moving the bottom

⬇ In the original image the sky was pale, with very little color. By adjusting the individual color channels accessed in the drop-down menu, I was able to plot some holding points before adjusting the color of the sky (represented as the light tones at the top of the graph) to make it blue.

of the line; conversely, the same effect can be made with the highlights at the top.

To target your adjustments, you need to plot a few holding points down your line: where you place these depends on which tones you wish to adjust. Your curve will commonly result in a shallow S shape. This lessens the contrast in the highlights and shadows while increasing contrast in the midtones. By creating this curve you can often enhance detail and give your image a bit of

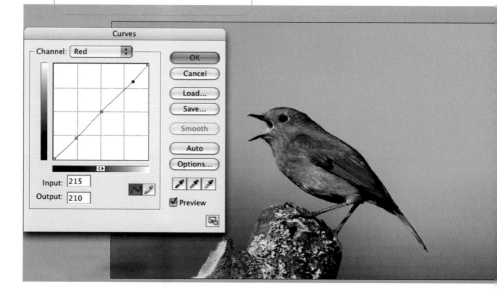

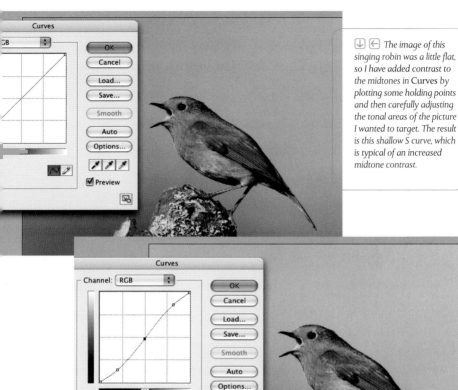

↧ ← *The image of this singing robin was a little flat, so I have added contrast to the midtones in* Curves *by plotting some holding points and then carefully adjusting the tonal areas of the picture I wanted to target. The result is this shallow S curve, which is typical of an increased midtone contrast.*

nch. Of course, not all images are going to ed this treatment, and you might be able to ate the desired effect in *Levels*. What *Curves* es give, however, is added control—the more u use it, the more efficient you will become at king the very best of your images.

Finally, mention should be made of the *adows/Highlights* tool in Photoshop CS2. s can be an excellent alternative to fiddling und in Curves and is very useful to bird otographers since it helps bring out detail ooth shadow and highlight areas. However, rdoing the use of this tool will result in ty halos or a very flat overall image; like all ustment tools in Photoshop, the bottom line lways to trust your judgment.

PRO TIP

If you want to make very localized adjustments to your image, hold down your mouse button and the cursor will become an eyedropper when you move it over your image. The corresponding point will be shown on the *Curves* graph wherever you place the eyedropper. Therefore, if you have an area of the picture you want left alone, you can place anchor points to protect it.

HOWEVER CLEAN YOU KEEP YOUR CAMERA'S SENSOR, IT IS INEVITABLE THAT SPECKS OF DUST WILL FIND THEIR WAY ONTO IT. THIS CREATES BLEMISHES ON THE IMAGE, WHICH CAN BE VERY OBTRUSIVE. THESE TWO TOOLS CAN BE USED TO ELIMINATE BLEMISHES.

The Clone Stamp and Healing Brush

Dust is the digital photographer's greatest enemy, and no matter how careful you are, you will end up with dust on your sensor, causing dust spots to appear on your images. These need to be removed by either the *Clone Stamp* or one of the *Healing Brush* tools.

Although they do the same job, these two tools differ in how they work. The *Clone Stamp* works by the user selecting an adjacent area to the spot you wish to remove, and then stamping that sampled piece of the image over the offending spot. You sample by first selecting a brush size—either by using the square brackets on your keyboard or from the brush palette—and then choosing the area you wish to clone from. Click Alt (Opt) and then place your brush over the spot for cloning.

If you are doing a lot of cloning, whether that involves removing multiple dust spots or a obtrusive background feature, then take care o

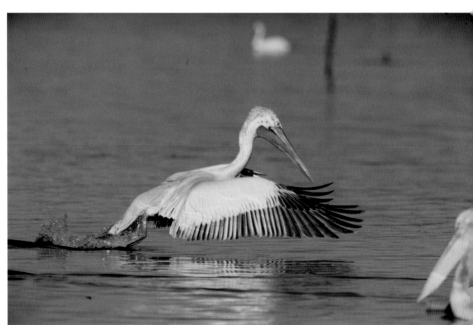

here you clone from, so that you do not leave
n obvious trail of cloned patches. Done properly,
our work should be undetectable.

The *Healing Brush* is often the superior choice
hen cloning out dust spots. Where the *Clone
amp* wins is in areas of sharply contrasting edges,
ch as on the plumage of a bird or a critical piece
 background. The *Healing Brush* works in much
e same way as the *Clone Stamp*, but copies the
xture of the source. In CS2, the *Spot Healing Brush*
 even better, since it needs no sampling; all you
ed do is place the cursor over the offending area
d click—this is great for speed when eradicating
st spots from areas of sky or water.

When eradicating dust spots, you need to
 zoomed in to 100 percent (double-click on
e *Magnify* tool), then systematically work your
ay across the image. I start in the left-hand top
rner and gradually move to the bottom right,
vering the whole image accurately. When using
e stamps, the brushes need to be reasonably
rd—the more detailed the area to be cloned,
e harder the brush should be. The *Healing
ush* should never be soft, as this prevents
e healing function.

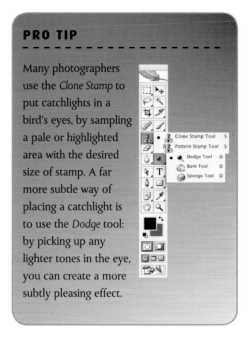

PRO TIP

Many photographers
use the *Clone Stamp* to
put catchlights in a
bird's eyes, by sampling
a pale or highlighted
area with the desired
size of stamp. A far
more subtle way of
placing a catchlight is
to use the *Dodge* tool:
by picking up any
lighter tones in the eye,
you can create a more
subtly pleasing effect.

The before-and-after effect of using the
Clone Stamp *to tidy up this image of a Dalmatian
pelican at Lake Kerkini in Greece transformed
what was a messy snapshot into a study of the
pelican's flight, by placing emphasis on the subject.*
500mm lens; ISO 160; 1/1000 sec at f/8

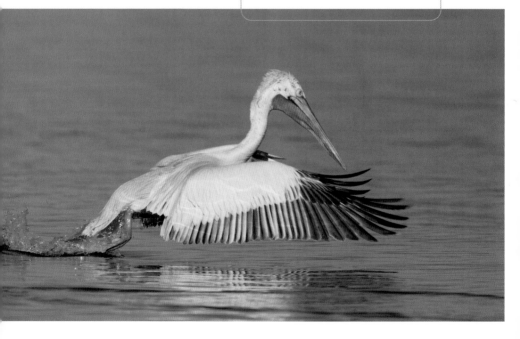

Resizing and output formats

There may be times when your file size is not big enough to produce a large print. The answer is to add more pixels to the image to enlarge the file size. This process is called interpolation.

A badly prepared file will interpolate poorly, as any imperfections in the image will be magnified, therefore it is good practice to optimize your image as best you can. When shooting in RAW and knowing the size of file you will need, you can interpolate before entering Photoshop. If working with a JPEG or processed TIFF file, you need to do this in Photoshop or with a third-party plug-in—a number of options are available, with the most popular being Genuine Fractals. I have compared Genuine Fractals with the bicubic method available in Photoshop, and I can see no advantage. There has been a long-standing school of thought that advises interpolating by using a step method, enlarging by 10 percent or so each time, but this has

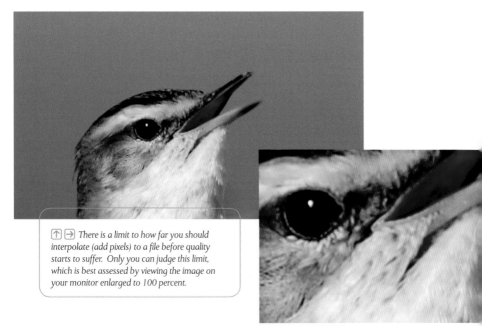

⬆ ➡ *There is a limit to how far you should interpolate (add pixels) to a file before quality starts to suffer. Only you can judge this limit, which is best assessed by viewing the image on your monitor enlarged to 100 percent.*

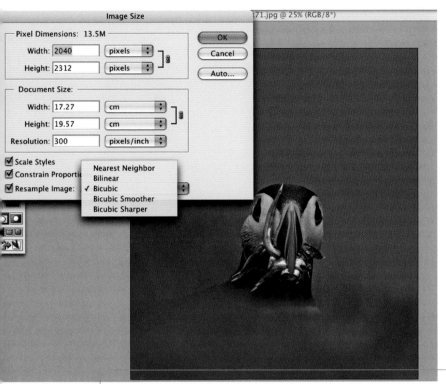

⬆ The **Image Size** box both informs you of the picture's size and dimensions, and allows you to either reduce or increase the size of your image. To do this, either increase or decrease the number of pixels or change a value under **Document Size**. Change one value, and the others will automatically adjust. When enlarging an image you should have all three boxes at the bottom checked off, and choose one of the algorithms (processes) listed in the drop-down menu under **Bicubic**. When interpolating (enlarging), choose **Bicubic Smoother** for the best results.

ow been proven to give poorer results than nterpolating in just one step.

To interpolate in Photoshop, go to *Image > Image Size*; then, starting at the bottom, check he three boxes. The drop-down menu next to *Resample Image* gives the algorithm options for esizing: *Bicubic Sharper* can be used to reduce file size, for enlarging you should use *Bicubic Smoother*. Above are the *Document Size* values nd *Pixel Dimensions*; changing the value in one ox will automatically adjust the values in the ther, so you need to change one of the sets f values for your enlargement.

Finally, if you have been working with a PEG, you are likely to want to save your image s a JPEG. If you have been working from a RAW le, to retain the best quality, you should save

your image as a TIFF. Click *File > Save As*—this gives you the option of changing your file name and allows you to choose a location to save the image in, and in which format. The latter gives a drop-down menu from which you click your selection. If saving as a JPEG, you will be given a further option of choosing a quality setting.

PRO TIP

Remember never to sharpen the image before interpolating. By doing so, artifacts (imperfections) created by sharpening will be magnified, which may lead to a noticeable loss in image quality.

THERE ARE MORE THEORIES ABOUT SHARPENING THAN ANYTHING ELSE IN
DIGITAL PHOTOGRAPHY. EXPERTS HAVE DIFFERENT IDEAS ON THE BEST WAY
TO SHARPEN, AND YOU SHOULD REVIEW WHAT THEY DO, BUT THERE IS NO
SUBSTITUTE FOR EXPERIMENTING YOURSELF.

Sharpening

All digital images need some amount of sharpening before being
printed. Sharpening should be your last act before output, and ideally
no or very little sharpening should have been applied either in your
camera or in Photoshop. The reason for this is that sharpening will
introduce artifacts that degrade the picture, but these will not be
visible if sharpening at the end of the work flow and if you do not
oversharpen. If you were to sharpen before making color adjustments
and retouching, these artifacts would be accentuated; even worse
is sharpening before interpolating the image.

Sharpening effectively boosts contrast along
edges in the image, which is why when you
increase an image's contrast it appears to
become sharper. You cannot sharpen a picture
that was not in sharp focus in the first place,
because the extra detail looked for was never
captured in the photograph.

The sharpening tools are found under *Filter*
in Photoshop. There are two that are relevant:
the *Unsharp Mask* (USM) filter has traditionally

⬇ The **Unsharp Mask** *palette found in* **Filter >
Sharpen**. *You can sample various parts of your
bird with the cursor to check on the effects of the
level of sharpening being applied.*

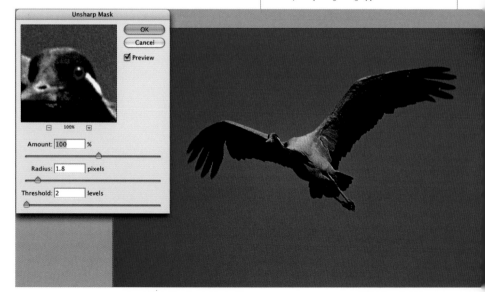

een the tool to use, and Photoshop CS2 now also atures *Smart Sharpen*, which gives the option of arpening shadow and highlight areas separately.

Whether using *Unsharp Mask* or *Smart arpen*, or sharpening tools in other software, member that sharpening is very subjective. I e many prints where the sharpening has been verdone, while pictures are often published here clearly not enough sharpening has been pplied. The sharpening effect you see on the reen will not necessarily translate to the same egree on your print—this difference is even ore pronounced when images are published, the preparation of an image for press creates loss in sharpness. Because sharpening is t a science, you need to experiment; once xperienced in the art, you will be able to

judge the level of sharpening required for your proposed output.

The amount to sharpen in percentage terms will vary from image to image, but typically I never go above 200 percent. The *Radius* and *Threshold* settings affect the distribution of sharpening. The *Radius* affects the area by the increased contrast—a setting between 1 and 2 should be sufficient here. *Threshold* measures contrast between pixels—the higher you go, the less your image sharpens. Again, you need to experiment for the effect you desire.

PRO TIP

Sometimes when using *Unsharp Mask*, you might find that if you have areas of high contrast—some twiggy branches against a bright blue sky, for example—that nasty highlight halos can occur along the edges of branches. By using *Smart Sharpen*, such problems can be avoided.

⬆ *This series of images shows the original unsharpened image, an image sharpened an optimum amount, and an image that has been oversharpened. Sharpening is more of an art than a science; you may feel the need to experiment a little to refine your judgment on how much each image will need for your desired output.*

THE PRICES OF INKJET COLOR PRINTERS HAVE TUMBLED OVER THE YEARS, BUT DON'T
BE TEMPTED TO BUY THE CHEAPEST AVAILABLE, AS THE RESULTS WILL LOOK CHEAP,
TOO. YOU WANT THE BEST FOR YOUR IMAGES, SO GET THE BEST YOU CAN AFFORD.

Printing

**Printing your bird pictures at home on your desktop is a great way
to enjoy your growing photography skills and, of course, the birds
you have seen. There are many inkjet printers on the market, but
as a brand, Epson leads the way—not only in hardware but also
in the inks and papers they produce.**

Inkjet printers work by spraying droplets of
ink onto paper that are so small they are
indiscernible to the naked eye. Generally
speaking, the bigger the prints you want to
make, the bigger the machine and the more
this will cost. While lower-cost machines usually
have four colors, the more expensive and larger
machines generate six or seven colors—more
accurately, they add tones such as light gray
and pale versions of cyan and magenta. These
machines give you improved, smoother tonal
gradations. That said, many of these differences
may not be readily discernible to the average
viewer, particularly in images of birds.

Printers are relatively cheap to buy; your
major costs will be paper and ink. If you intend
to do a lot of printing, you might want to look at
the various options for ink: some printers have
just one cartridge supplying all the colors, some
have individual color cartridges, and others still
have cartridges that can be refilled with ink. Your
choice will be down to economics, but pigmented
inks will give you the best life expectancy when
matched with archival papers. Which kind of
paper you choose is down to personal preference.
Canvas is currently very popular, as are fine-
art watercolor papers, or you can go for more
traditional matte or gloss paper.

Printer resolution and image resolution are
often confused. Printer resolution is how the ink
is put down on the paper, expressed as dots per
inch (dpi). A resolution of 1440 x 720dpi will
give excellent results. Image resolution, on the
other hand, is made up of the pixels per inch in
your image and is referred to as ppi (this is often
referred to incorrectly as dpi). For the best result
when printing, a figure of 240–300ppi should be
used. This figure is set in *Image > Image Size*
in Photoshop.

The file size of your image needs to be large
enough for the size of print you plan to produce,
if you want to get the best quality print possible.
Prints produced too large for their file size may
appear acceptable, but the chances are that they
could be improved by using the correct file size.
As a simple guide, a good 8 x 10 inch print needs
a file size of 15–20Mb. If you have a digiscoped
image, for example, with a 12Mb file, you will
need to interpolate a little for the best result.

Although printmaking is an art rather than
a science, you should aim to remove as much
of the guesswork from it as possible. Strive
for accuracy in producing a print that closely
matches the image displayed on your monitor by
calibrating both your monitor and printer. As with
your monitor, your printer needs an ICC profile s

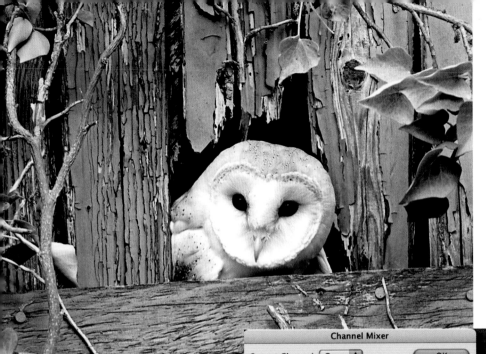

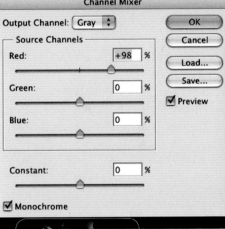

Channel Mixer

Output Channel: [Gray ▼]

— Source Channels —

Red: [+98] %

Green: [0] %

Blue: [0] %

Constant: [0] %

☑ **Monochrome**

[OK]
[Cancel]
[Load...]
[Save...]
☑ Preview

⬆ *Making prints of your photos can be very rewarding. I converted this image of a barn owl from color to black and white. You can do this in Photoshop by discarding all the color information to convert to a grayscale image; however, this can give a flat, very gray-looking result. For a punchier conversion, go to* **Adjustment Layers > Channel Mixer**. *You can then play around with the sliders for your desired effect. Just make sure you have the monochrome box checked.*

⬆ *The* **Channel Mixer** *palette for conversion from color to black and white.*

can accurately interpret the color information eing sent to it by your computer. Printers have eneric profiles that are often adequate, and the prints you produce are a decent enough match for your needs, you might not feel the eed to do any more. Far more accurate are printer profiles that match printers with specific aper combinations; these can be bought off e Internet. You can take this a step further and create a custom profile or get a profiling service to do this for you. Once your printer is profiled ith the inks and paper you use, you should get onsistent results, as your printer and monitor will be talking the same color language, so to speak.

One common problem you may encounter hen using inkjet printers is clogging of the printer head, which can cause lines or very odd

colors to appear. This may be caused by the use of third-party inks; in addition these inks will not be of a high quality, and chances are the colors on your print will not be as accurate as they could have been—saving money on inks is normally a false economy. Heads can be cleaned either by the printer utility within the printer's software, or in some models by pressing a button on the front of the printer—see your manual for details.

WHETHER YOU USE A COMPACT CAMERA FOR DIGISCOPING OR A DSLR, THERE IS NO
REASON WHY A GOOD BIRD IMAGE SHOULD NOT BE ACCEPTABLE FOR PUBLICATION.
THERE IS A LOT OF COMPETITION, HOWEVER, AND YOU NEED TO BE ABLE AND
WILLING TO GET YOUR WORK SEEN.

Getting published

There are few people who take pictures who do not have an ambition
to have their work published. There was a time when many bird
magazines, particularly in Great Britain, had most of their images
supplied by a few dedicated bird photographers. The boom in digital
bird photography, and particularly in digiscoping, has changed all that:
open any bird magazine today, and you will see a multitude of
different names sprinkled throughout the picture credits.

Digiscoping rare birds has been the route into
being published for many, since there is a
constant hunger for images of newsworthy birds.
The ease of photographing rarities by digiscope,
however, means competition is fierce. I know of
one bird magazine that, after a good weekend

for rare birds in spring and fall, often receives
over two hundred e-mailed images in a day!

While digiscoped images are fine for small
reproductions in bird magazines, if you are
serious about being published you need to
shoot with a DSLR to produce the quality detail

quired. If you can write, great; magazine editors
ve features that have a strong pictorial content,
nd offering a complete package of words and
ictures is an attractive proposition for editors,
ompared to offering just one or the other. There
re some wildlife photographers who make a
nodest living by writing and supplying images
o magazines—just don't expect to get rich.

There are many other routes to selling your
vork. Note that I say "sell"—I would urge you
ever to give your work away for free, as this
ets a bad precedent and you are simply allowing
ourself to be taken advantage of. Photographs
re valuable commodities that sell products,
acations, and most other things we consume in
fe. Be wary of tour operators inviting images to
e sent for publication in their brochures—you
nay get the warm glow of seeing your work in
rint, but in reality your work will be devalued,
s the use of it is just the cheap option for those
usinesses. Similarly, be wary of photographic
ompetitions that hide away a clause giving them
ne right to use your pictures for anything and
verything, forever, and for nothing.

Emperors of the Weddell Sea
David Tipling

The members of Scott's ill-fated 1911 expedition
to the South Pole were the first humans to
witness an Emperor Penguin rookery. In the
past decade, however, with the break up of the
Soviet Union and the resulting availability of
Russian ice-breakers suited for Antarctic explor-
ation, tourism to the great white continent has
boomed. Nevertheless, the logistics of reaching
Emperor Penguin colonies remain daunting.
Every couple of years, Antarctic cruises visit
some of the more accessible colonies, usually
ferrying people in by helicopter from an ice-
breaker. However, the earliest that these trips
run is mid November and generally they are in
early December, while time at the colonies is
limited; such an arrangement is ideal if you
wish to experience a colony, but for serious
photography such a trip can be highly
frustrating.

So, when the opportunity arose to join an
expedition camping on the sea-ice next to a
colony for a minimum of 10 days, I jumped at
the chance. Such expeditions do not come
cheap; with a barrel of fuel on Antarctica worth
in the region of $5,000, and with the knowledge
that one barrel will keep a Twin Otter airborne
for half an hour, you do not have to be Einstein
to realise that Antarctic travel is a costly
business. Despite this, the places on the trip
were filled quickly by wildlife photographers
from around the world.

Travel in Antarctica is at the mercy of the
weather, and trips that depart on time are just
about unheard of. We had a delay of six days.
In 1991, a similar expedition had been delayed
for three weeks. On the 4th November 1998,
after a final weather check, we boarded the
Hercules C-130 for our southbound trip from

Emperor Penguin Aptenodytes forsteri, Dawson-Lambton Glacier, Weddell Sea, Antarctica, November 1998
(David Tipling/Windrush). 'Once the colony came into view, we were all speechless.'

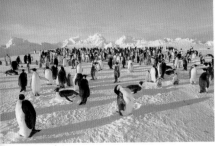

477

*← ↓ Four examples of how some of my images
have been used. Although there is not a huge
market for images of specific bird species, there
is a hunger for images that are generic in nature,
and if they mirror human emotion, as with some
of these examples, then they are suitable for all
manner of uses, such as advertising, book covers,
greeting cards, and jigsaws.*

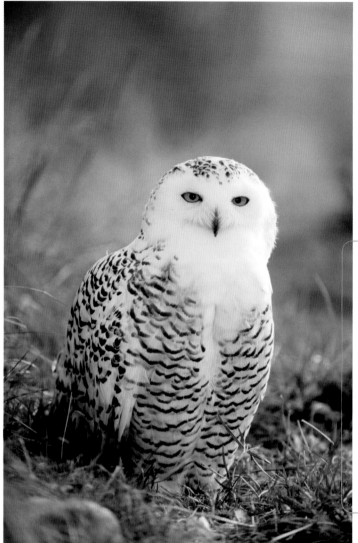

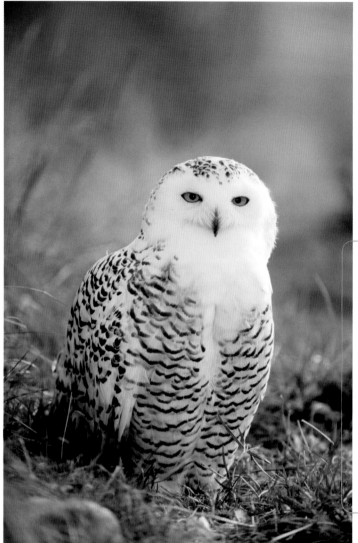 *When taking images for publication, leave plenty of space around the bird. Cropping too tightly will reduce the chances of your picture being chosen, as designers often need surrounding space to accommodate other elements such as text and logos. With this image of a snowy owl looking at the camera, I have left space at the top of the frame for type. This would be ideal as a book or magazine cover, not least because the bird is looking directly at the camera, engaging the viewer.*

500mm lens; ISO 160; 1/500 sec at f/8

You may decide you want someone else to market your pictures for you, in which case you need an agent. Agents have big overheads that include a lot of promotion, running Web sites, and paying staff, so they typically take at least 50 percent from each sale they make for you. Having an agent does not guarantee lots of sales; the market for bird pictures is relatively small, especially for the more obscure species. Couple this with the flood of fantastic images being taken year after year, and know that there is plenty of competition.

To make sales, your work needs to stand out and building a niche for yourself by developing a distinctive style or specialization will help. In my early days, I built up an extensive coverage of British garden birds and became well known for those images within the business.

As well as using agents, I market my own work quite aggressively, both through direct contact with potential clients and through a Web site. These have proliferated in recent years, and if you have a good site with plenty of images online to choose from, you are likely to get picture buyers using

ou regularly—too little choice means buyers are
ot likely to waste their time. To combat this
roblem, some photographers have joined together
• promote their bird pictures on one common
te, giving buyers a decent choice. This kind of
ooperation is likely to increase in the future.

Entering competitions successfully is another
ay to see your images in print being enjoyed
y a wide audience. The International Wild Bird
hotographer of the Year is perhaps the best-
nown competition for bird photographers.
ompetitions are a big lottery however, as
hotography is so subjective that you cannot say
efinitively that one image is necessarily more
esthetically pleasing than another. We all have
ur individual tastes based on particular personal
xperience, so when choosing images for a
ompetition, you can often be too close to your
ork to make an objective judgment. Show a set

of images to family and friends, and if they
consistently pick certain images as their favorites,
the chances are these will be the pictures that
appeal to the judges, too.

If you simply want to share your photos, you
can have a Web site, or you can contribute to
one of the many forums and Web sites devoted
to birds on the Web. Surfbirds (www.surfbirds.
com) is one of the best known and is particularly
popular with digiscopers wanting to share images
of rare birds. There are many others; often you
can make good contacts through them, and
they can be a source of very useful information,
whether it be for good sites to photograph birds
or simply for ideas on technique or equipment.

> ⬇ *Birdwatching is booming, with more and more
> people discovering our rewarding pursuit, and as a
> result there are lots of opportunities for capturing
> images of people actually birdwatching.*

YOU WILL HAVE A LOT OF BIRD IMAGES TO STORE, SO A LOGICAL FILING SYSTEM
IS INVALUABLE IN HELPING YOU TO FIND THEM AGAIN QUICKLY. WHEN STORING
IMAGES, AS WELL AS BEING EASY TO ACCESS, THEY ALSO NEED TO BE SECURE,
SO KEEP THEM SAFELY BACKED UP ON CDS OR DVDS.

Long-term storage of pictures

Deciding on how to store images for the long term will depend largely on how many you take and whether you shoot JPEGs or RAW—if you use the latter, you will need a lot more storage capacity than for the former.

When you store your images they need to be cataloged in some way, so that individual pictures can be found easily. There are many ways of doing this, and you need to think about the best system for you. Because I sometimes take hundreds of images a month, I file my images in folders under bird's names, which are then placed in folders titled with the relevant families. Thus, if I want to look at all my osprey images, for example, I can click on the "Birds of prey" folder, and within that the "Osprey" folder.

My images are stored on external hard drives that connect to the computer, and I keep two backup drives in case of failure, one of which is at another address. I go to great lengths to protect my images because they are my livelihood, but whatever the level of interest you have, you should have your images backed up at least once. Hard drives do fail, and if you do not back up, then you run the very real risk of losing everything.

The other option is to store your images online, or on CDs or DVDs. Longevity of these latter media has never been proved, as they have not yet been around for long enough. The safest option is to transfer your backed-up files

⬅ ⬇ *Hard drives can be so small that they fit on your key ring. However, larger versions such as this LaCie model can hold hundreds of gigabytes (Gb) of data and are better value.*

from their CD or DVD format to new CDs or DVDs every five years or so, thus avoiding the media degenerating in the long term. If choosing disks for long-term storage, go for those that have gold in their dyes—gold does not degenerate very quickly and is reflective. Disks with poor reflectivity properties in their dyes are those that CD and DVD players struggle to read after a while. While CDs are restricted to 700Mb of data, a DVD will allow you to store around 4.2Gb of data, and so these are more suited to photographers who shoot in RAW.

⬅ ⬇ *The process of filing and retrieving an image.*

➡ *When I want to retrieve this image of a redwing, I simply go to my "Birds" folder; inside this I click on "Thrushes" and then "Redwing." I store images on three different hard drives in case of failure.*

500mm lens; ISO 100; 1/500 sec at f/4

HOPEFULLY, YOU PHOTOGRAPH BIRDS BECAUSE YOU LOVE AND ADMIRE THEM, AND WANT TO TRANSLATE THIS INTO RECORDING THEIR EXISTENCE. DON'T ALLOW YOUR ENTHUSIASM OR DESIRE FOR THE PERFECT PICTURE TO OVERRIDE EITHER THE HONESTY OF YOUR PHOTOGRAPHS OR THE WELFARE OF YOUR SUBJECTS.

Ethics and the bird photographers' code

The old saying "a photograph never lies" is now well and truly out of date. There was a time when wildlife images could be trusted as exact representations of a scene captured by the photographer. Now we have the means to composite images from many different pictures, to add extra birds or place a bird in a different setting—the imagination is really the only limit. "Photographic artist" is a name being increasingly used to describe photographers who regularly manipulate their images; and indeed, this practice is helping to develop wildlife photography as an accepted form of art.

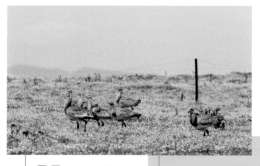

All digital images need some manipulation to color and other variables to optimize the shot; backgrounds can be tidied up or made more blurry, for example. Where the photographer does have a duty is in stating when an image has been materially altered to such an extent that it no longer represents the scene viewed

⬆ ➡ *I see no problem with tidying up backgrounds, as in this example of a flock of great bustards, where I have removed the fence and improved the colors. I would not, however, add birds to the image or materially change the scene without declaring this in the image caption.*

200mm lens; ISO 100; 1/500 sec at f/11

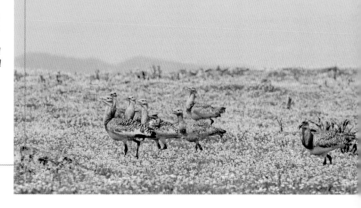

⬆ *A number of species are legally protected against disturbance; for example, it is illegal to photograph ospreys in the nest in Great Britain without the relevant license. This image was taken in Finland.*

500mm lens; ISO 100; 1/350 sec at f/8

the time. Without such disclosure, how can we marvel at the natural world through the eyes of photographer without wondering whether what e are viewing is reality? Some photographers gue that it is the end result that matters, and at how the image was made is immaterial. is is fine if your only consideration is the esthetics of an image, but by not declaring at an image is a composite you are damaging e integrity of other wildlife photographers, as e viewing public can lose trust in whether an nage is a true representation.

Although we do not have an official bird notographers' code, there are a number of pints worth considering. It has been said many nes but is worth saying again: the welfare your subject should always come before the notograph. Hounding tired migrants or rarities ads to both photographers and birdwatchers etting a bad name. You should respect private nd, particularly when it comes to erecting

blinds. Nest photography these days is very much out of fashion, but if you do wish to photograph birds in a nest, some rules need to be observed: gardening around the nest should be kept to an absolute minimum, and if vegetation needs to be moved, then it should be tied back, not cut. Blinds should be moved into position slowly over a period of days, and photography should be abandoned if the birds you hope to photograph have an adverse reaction to any intrusion.

Many species require a license for photography of birds in or near the nest. You should be fully conversed in your country's legal requirements in this regard.

Glossary

Aperture: The opening in the lens through which the flow of light to the camera is regulated.

Artifact: A flaw in a digital image.

Bit: The smallest unit of data of binary computing. Eight bits make one byte. An 8-bit image contains 256 colors, a 16-bit image roughly 32,000.

Bit depth: The number of bits of color data for each pixel found in a digital image.

Buffer: Temporary storage space in a camera, where images are held before processing and transfer to the camera's memory card.

Burst depth: The number of images you can take before the camera's buffer fills and prevents you from taking any more.

Burst rate: The number of frames the camera can take per second.

CCD: Charge Coupled Device. A type of imaging sensor used in digital cameras (see CMOS).

Clipping: The loss of detail in an image due to poor exposure.

CMOS: Complementary Metal Oxide Semiconductor. The other main type of imaging sensor found in digital cameras (see CCD).

Color temperature: A way of measuring the amount of red, green, and blue light emitted from a light source. Measured in degrees Kelvin.

Compression: A way of reducing the size of an image file by removing some image data.

Depth of field: The zone of sharpness in a image.

dpi: Dots per inch. A measurement of how many dots of ink a color printer can put down.

File format: A way of storing image data in a file, including JPEG, RAW, and TIFF.

Gamma: The intensity of the output signal relative to the input. Reference is made to Gamma when calibrating monitors.

Gamut: The range of colors a device such as a monitor or printer can produce. Colors a device cannot produce are described as "out of gamut."

Gigabyte: A unit of computer memory or data. One gigabyte (Gb) equals approximately 1,000 megabytes (Mb).

Histogram: A graph that maps the number of pixels across all tones in an image.

ISO: The international standard rating for film speed, used in digital cameras to set the sensitivity to light of the sensor.

JPEG: A file format that uses lossy compression, which means that quality can be compromized.

Megabyte: A unit of computer memory or data storage capacity equivalent to 1,024 kilobytes or 1,048,576 bytes of data.

Megapixel: A resolution rating for digital cameras. The higher the figure, the higher the resolution created by the camera.

Noise: Random pixels on a digital image created by too high an ISO rating, poor exposure, or poor image-processing by the camera.

Pixel: Short for picture element, pixels are the dots of single tones and colors that are the basic building blocks of a digital image.

Plug-in: Third-party software that supplements features of an existing program. For example, plug-ins for Photoshop can include software for sharpening, dealing with RAW images, etc.

ppi: Pixels per inch. Relates to actual pixels in the photograph.

RAW: A digital camera file format storing the maximum possible information as captured by the camera's sensor.

Resolution: The level of detail a device produces, measured in dpi or ppi.

RGB: Red, Green, and Blue. The primary colors.

TIFF: Tagged Image File Format. This is a format that is lossless.

Tonal range: The range of tonal values in a image.

White balance: Used to eliminate unwanted color casts. White balance can be set in camera or adjusted later if shooting in RAW.

Resources

Web addresses

www.adobe.com

www.canon.com

www.dpreview.com for technical reviews

www.epson.com

www.kirkphoto.com for excellent window mounts

www.nikon.com

www.pocketwizard.com for wireless triggers ideal or remote-control photography

www.rue.com for blinds

www.luminous-landscape.com for many resources in digital photography

www.robgalbraith.com for up-to-date news on digital equipment, including reviews and technical discussions

www.tripodhead.com for tripod heads (including Wimberly heads) and other gadgets

Books

Photoshop for Nature Photographers, **Ellen Anon and Tim Grey, Sybex, 2005:** a good guide to working with your bird images in Photoshop.

Adobe Photoshop CS2 for Photographers, **Martin Evening, Focal, 2005:** this is the Photoshop bible, well worth having on your shelf as a reference.

Bird Photography: Choosing the Best Destinations, Planning a Trip, Taking Great Photographs, **David Tipling, Photographers' Institute Press, 2005:** my guide to some of the best locations to photograph birds around the world.

The Complete Guide to Digital Color Correction, **Michael Walker and Neil Barstow, Lark, 2006:** a great guide for coming to grips with color issues.

Index

Acknowledgments

There are many people dotted around the world who have assisted me over the years in taking many of the images in this book. They know who they are, and to them I say a big thank you.

I would also like to thank Charley Hayes and Tim Hunnable from Nikon (UK) Ltd.

The Girl Who Struck Out Babe Ruth

9/67

by Jean L. S. Patrick
illustrations by Jeni Reeves

On My Own

HISTORY

DISCARDED

M Millbrook Press/Minneapolis

...midt, who slid into home plate
...d captured the heart
...my grandpa
— *J.L.S.P.*

The author and artist would like to thank all who provided assistance, including Lee Anderson, W. C. Burdick, Jerry Desmond, David Estabrook, Bill Francis, David Jenkins, Tom Nieman, Suzette Raney, Brad Smith, the Chattanooga-Hamilton County Bicentennial Library's Local History Department, the Chattanooga Regional History Museum, and the National Baseball Hall of Fame. And the artist would like to give special thanks to her model, Karen Dodd.

This book is available in two editions:
Library binding by Millbrook Press, Inc., a division of Lerner Publishing Group
Soft cover by First Avenue Editions, an imprint of Lerner Publishing Group
241 First Avenue North, Minneapolis, MN 55401 U.S.A.

Website address: www.lernerbooks.com

Library of Congress Cataloging-in-Publication Data

Patrick, Jean L. S.
 The girl who struck out Babe Ruth / by Jean L. S. Patrick ; illustrated by Jeni Reeves.
 p. cm. — (On my own history)
 Summary: A retelling of the day Jackie Mitchell, a seventeen-year-old female professional baseball player, struck out the New York Yankees' best hitters, Babe Ruth and Lou Gehrig, in an exhibition game in 1931.
 ISBN-13: 978-1-57505-397-4 (lib. bdg. : alk. paper)
 ISBN-10: 1-57505-397-4 (lib. bdg. : alk. paper)
 ISBN-13: 978-1-57505-455-1 (pbk. : alk. paper)
 ISBN-10: 1-57505-455-8 (pbk. : alk. paper)
 1. Mitchell, Jackie, 1914–1987—Juvenile literature. 2. Ruth, Babe, 1895–1948—Juvenile literature. 3. Gehrig, Lou, 1903–1941— Juvenile literature. [1. Mitchell, Jackie, 1914–1987. 2. Baseball players. 3. Baseball—History. 4. Women—Biography.] I. Reeves, Jeni, ill. II. Title. III. Series.
 GV867.5.P377 2000
 796.357'092—dc21 99-033322

Manufactured in the United States of America
7 8 9 10 11 12 – JR – 11 10 09 08 07 06